Spiritual Sisterhood

Mentoring for Women of Color

Rebecca Florence Osaigbovo

IVP Books

An imprint of InterVarsity Press
Downers Grove, Illinois

InterVarsity Press
P.O. Box 1400, Downers Grove, IL 60515-1426
World Wide Web: www.ivpress.com
E-mail: email@ivpress.com

InterVarsity Press® is the book-publishing division of InterVarsity Christian Fellowship/USA®, a movement of students and faculty active on campus at hundreds of universities, colleges and schools of nursing in the United States of America, and a member movement of the International Fellowship of Evangelical Students. For information about local and regional activities, write Public Relations Dept., InterVarsity Christian Fellowship/USA, 6400 Schroeder Rd., P.O. Box 7895, Madison, WI 53707-7895, or visit the IVCF website at <www.intervarsity.org>.

All Scripture quotations, unless otherwise indicated, are taken from the Holy Bible, New King James Version.

While all stories in this book are true, some names and identifying information in this book have been changed to protect the privacy of the individuals involved.

Design: Cindy Kiple
Images: woman with greeting card: Comstock Images/Getty Images
African American woman: digitalskillet/iStockphoto

ISBN 978-0-8308-3830-1

Printed in the United States of America ∞

Library of Congress Cataloging-in-Publication Data

Osaigbovo, Rebecca.
 Spiritual sisterhood: mentoring for women of color / Rebecca
Florence Osaigbovo.
 p. cm.
 ISBN 978-0-8308-3830-1 (pbk.: alk. paper)
 1. African American women—Religious life. 2. Mentoring—Religious
aspects—Christianity. I. Title.
 BR563.N4O84 2010
 259.082—dc22
 2010040601

| P | 18 | 17 | 16 | 15 | 14 | 13 | 12 | 11 | 10 | 9 | 8 | 7 | 6 | 5 | 4 | 3 | 2 | 1 |
| Y | 26 | 25 | 24 | 23 | 22 | 21 | 20 | 19 | 18 | 17 | 16 | 15 | 14 | 13 | 12 | 11 |

The older women likewise, that they be reverent in behavior, not slanderers, not given to much wine, teachers of good things—that they admonish the young women to love their husbands, to love their children, to be discreet, chaste, homemakers, good, obedient to their own husbands, that the word of God may not be blasphemed.

TITUS 2:3-5

Contents

Preface

—❦◎—

\mathcal{M}y dear friend Julia Meadows has been doing neighborhood Bible studies for years. Just shy of eighty, she has eight children (six living), nine grandchildren and sixteen great-grandchildren. She was a stay-at-home mom, working only a few years at a Bible bookstore and a few years for a state unemployment office. She uses her home and her spiritual gift of teaching to help women grow in the Word and in their relationship with the Lord.

I wanted to be around Sister Meadows, so some years ago I began attending one of her Bible studies. Women came from all around town to study under her guidance, sitting around her dining-room table every Monday. Several of her sisters were present, and all attended the same family church. Their playful teasing and banter made the atmosphere homey and comfortable. Their love for the Lord and his people was evident in their conversation and in their warm reception of anyone who walked through the door.

On any given Monday, we would study anything from the book of Acts to how to be a woman after God's heart. After the study of the Word, Sister Meadows would make and serve a delicious lunch. The food, the family and the fellowship combined to create rich and open conversation in an atmosphere of love and acceptance, tempered by kind admonishments to live up to God's standards. It was both a comfort and a challenge to be around women who had known the Lord for many decades.

Sister Meadows has done this ministering for years, right in the middle of Detroit, a city beset with challenges yet buoyed by the hope that women like her represent.

Is there a mother in the 'hood? Are there mothers for the sisters? How do we ensure that mentor-mothering in the African American community regains its rightful place as a foundation to develop women who will help to transform the places where they live?

We need Christian women who will function as the spiritual mothers so critically important to the survival of the African American community. We need women who take seriously the task of teaching other women—women who desire to be obedient to their Lord Jesus because they love him. And we need young women willing to learn from them.

The purpose of this book is to help women to come alongside and teach other women. I trust its contents will challenge, encourage and help more African American Christian women who are mature pour into the lives of those who are younger. I also trust it will help younger women seek out and learn from their elder sisters in the Lord.

If you are a woman, you should either be a mentor or a mentee. You have no option. But it's one thing to know what you should do; it's another thing to be shown how to do it. My prayer is that by the time you finish this book, you will have the re-

sources to make mentoring happen, whether you are a mature woman investing in the life of a younger woman or a younger woman looking for a spiritual mom.

No matter what your story, no matter what your journey, you have something to say to somebody. It may be to one. It may be to three. It may be to hundreds or thousands. But take from what has been invested in you and give back. That's what spiritual mentoring is all about—giving back to others so they can have an easier way of being pleasing to God.

I'm talking about a revolution that will make a great positive difference in our communities. And no matter if you've been raised in a Christian home and have been in a church and around church folk all your life, no matter your age, you need to be a spiritual mother, and you need the input of spiritual mothers too.

—❦—

There is room for much more intentional discipleship, mentoring and spiritual mothering in our churches and among Christian women. Spiritual mothering has so much potential to make a major difference in individual lives, in families and in neighborhoods. The mothers in the 'hood are valuable, essential and necessary. We need to listen to them. We need their input in our lives.

That's why I have devoted space in this book to sharing stories from women, both mentors and mentees. You will hear from flesh-and-blood women who have practiced spiritual mothering, faced tough issues and made it work. I trust their stories will be a resource to help you make it work too. I trust they will be an encouragement to you to join with others in making sure that spiritual mothering increases in our community.

I will also define spiritual mothering, because it seems to be

a lost art. I'll do that by going to the source, the Word of God. I'll also show you some of the pitfalls inherent in spiritual mothering, and how to avoid them. Then we'll look at how Jesus, the master disciple-maker, made disciples. His methods have been put into practice by spiritually mature African American women who have intentionally set aside time to share their wisdom and life perspective with younger women.

—⚜︎

I do not want to make an assumption that everyone who is reading this book knows about how to be born again, so go to appendix A, "The Road to Salvation," at the end of this book to take a look at how the new birth takes place. This is important to anyone who is entering into a discipleship relationship, whether as a mentor or as a mentee. For many, this may just be a review, but reviews are good. Or it may lead a mentee—or even you—into the experience of the new birth.

> You could stand in a garage twenty-four hours a day, all week, and you will not turn into a car. The same is true of church. You can stay in church 24/7, and you will not become a Christian until you accept Jesus as your Savior.
>
> *Malettor Cross*

A note about terminology: We will be using the words *discipling, mentoring* and *spiritual mothering* interchangeably, even though technically they have different connotations. In this book, these all refer to the act of impacting the life of another person via teaching and modeling.

This book could have been titled "Spiritual Motherhood," but that would have placed the emphasis on the older women. If it had been titled "Spiritual Daughters," the emphasis would have been on the younger women. However, I want this book to

be a challenge to older women to let go of the excuses and be about the Father's business of spiritual mentoring, but I also want to offer help and encouragement to younger women who desire to be mentored, giving them practical ways to connect with an older woman. Although the peer relationship of Christian women is not discussed in detail in this book, sisters helping mentor each other is another example of spiritual sisterhood. So it is my intention that this book be a resource for spiritual peers or for any sisters who encourage, challenge and help each other do the Titus 2:3 thing.

Whether it is an older woman mentoring a younger woman, peers who encourage and help each other mentor younger women, or a younger woman who desires to be mentored by an older woman, the title *Spiritual Sisterhood* says it all. It's what I think takes place in the whole process of Christian women's relationships. *Spiritual Sisterhood* is inclusive from mother to daughter, sister to sister, and daughter to mother.

I have been magnificently blessed through older women over the years. I was not aware of the immensity of the impact until I was in the process of writing this book. As I reflected on some of the women God has placed in my life, I was impressed to get in contact with many of them and ask them to share words of wisdom they would give to younger women. So throughout this book, you will find their words in brief call-out quotations so that you might benefit from their relationship with God and their years of wisdom, gained from walking with him, as I have.

I challenge you to be part of the transformation of our communities by committing to the work of discipling younger women and of being discipled yourself. You can make an impact—and other women can make an impact on you. I also challenge you to find a sister and either mentor some young women together or else hold each other accountable to do so.

1

Making the Case

⟶⟨⟨⟩

*I*f I had to define the state of spiritual mothering in the African American community today, I would lift a phrase from a classic novel: it is both "the best of times" and "the worst of times." First the good news: discipleship is alive and well among women in the African American Christian community. Spiritual mothering has been going on in the African American community for a long time, as you will hear in a story about one born at the turn of the twentieth century who did this important work.

The bad news is, we don't have enough spiritual mothers. Spiritual mothering is in danger of becoming a lost art. Losing that gift, which primarily is passed down through generations, would be tragic, because spiritual mothering has much potential to make a major difference in individual lives, in families and in neighborhoods.

Spiritual mothers are valuable and necessary. We need them. We need to listen to them. We need their input in our lives.

There is definitely room for much more intentional discipleship to take place in our churches and among Christian women.

When I've asked African American female audiences how many had good spiritual mentoring or discipleship when they first became Christians, only one-third have consistently raised their hands. That's two out of three who have not had the benefit of being discipled. I do not propose that these informal and impromptu polls have any scientific significance, but if the results are anywhere close to reality, my guess is that a significant percentage of African American Christian women do not receive formal discipleship upon becoming a Christian.

It was not always this way. In what my daughter likes to call "the olden days," the extended family was operative in the African American community. The mother of the wife or husband often lived in the home. That grandmother, whom we frequently called "Big Momma," was an integral part of raising the children as well as the mother, showing her how to be a wife and mother, based on years of experience and biblical wisdom. Today, as we are more affluent and tend to move around the country, that is less and less our experience. It seems that we have lost the connection that ensured that a modicum of wisdom passed down through successive generations. This is sad, and a great loss among the people of God.

SPIRITUAL MOTHERING IS NOT AN OPTION

Spiritual mothering is not my idea. It is something God put in place. Jesus commanded us to "make disciples." And Paul spoke of spiritual mothering to Titus, one of the men he mentored and worked with. It's what God desires. It works, and it is vital.

I need to make it perfectly clear: discipleship is not an option; you are supposed to be a spiritual mother. If you aren't a spiritual mother, it may be because no one took the time to

disciple you, so you don't know what it is. Or maybe you just don't know how to do it. I really hope it is not because you just don't care about what God wants.

Women should disciple other women out of obedience to God. We disciple others because we love the Lord, and out of our love, we want to keep his commandment "Go therefore and make disciples of all the nations, baptizing them in the name of the Father and of the Son and of the Holy Spirit, teaching them to observe all things that I have commanded you; and lo, I am with you always, even to the end of the age" (Matthew 18:19-20).

Why should women in particular embrace teaching other women? Not only do older women not have an option, they have a biblical mandate to teach younger women: "The older women likewise, that they be reverent in behavior, not slanderers, not given to much wine, teachers of good things—that they admonish the young women to love their husbands,

Believe God's Word. Pray specifically; expect answers. Let the principles in the Bible guide your life.

Beverly Yates

to love their children, to be discreet, chaste, homemakers, good, obedient to their own husbands, that the word of God may not be blasphemed" (Titus 2:3-5).

This is serious. This is the Word of God. There is a purpose for older women to teach younger women—"that the word of God may not be blasphemed." Younger women need help in knowing how to love their husband and their children. We have to be committed to discipleship on every level.

Spiritual mothering predates even the authorship of that verse. Discipleship among females is as old as Ruth and Naomi (the book of Ruth) and Elizabeth and Mary (Luke 1). In the first example, we see an older Jewish woman, Naomi, mentor her wid-

owed daughter-in-law. Naomi never knew that her actions would put her and Ruth directly into the ancestry line of Jesus Christ, but her godly wisdom and graciousness made that possible. Mentor Elizabeth, the cousin of the woman who would give birth to that same Jesus, likewise played a very important role in Mary's development as a woman of faith and discernment.

The truth of the matter is that spiritual mothering has brought African American females a mighty long way, and it's what we desperately need to take us where we need to go. Even though we have a desire to increase it, we can't forget that discipleship is being done, as we will soon see in the examples we will talk about.

MENTORING IS GOD'S SCHOOL FOR LIVING

We go to school to learn math, English, history and other subjects, but not much is taught about living life. How do we manage life? How do we relate to men, such as our husbands? How do we both raise and impact our children? Where is the school for managing life, relationships and learning to make a good home? Those are some of the questions I had as a young adult.

Although that was years ago, I know some young adults today who seek answers to these same questions. They want to be able to ask someone who has "been there and done that." Sometimes people may not even know what they need, and if they do know, they may not know how to get what they need.

God has set up a school to help women get the answers they need. This school is relational. People have to connect with others—the older with the younger, the younger with the older. There is no classroom with desks or a chalkboard or maps on the wall. Older women being involved in the lives of other women is one of the most important ways Christian women grow and mature in their Christian walk. In fact, Christian

women can't mature without older women in their lives. That's the way God set it up.

I have had a wealth of input from mature women. As a result, God has been able to use me to minister to thousands of others. I can truly credit the women God has used in my life to pray for me, to teach me, to model Christ's life before me with being the major means God has used to train me as a minister.

The spiritual mothering of mature women has been a large part of making me who I am as a minister of the gospel. I have not been to any kind of Bible school or seminary. Though I am an avid reader, the influence and prayers of older women are what have truly helped shape me into a commissioned minister of the gospel of Jesus Christ. I have been privileged to be used by God to speak to and into the lives of thousands of Christian women via the avenues of writing, training and speaking at retreats, conferences and women's days. To his glory and certainly by his enabling, I have ministered in prisons. I have ministered in Uganda and Ethiopia. I have ministered to one person at a time, and I have spoken to many. I have trained people in Christian leadership. I have written books that have collectively sold over one hundred thousand copies. I am saying these things for no other reason than to point out that God has used me as a tool in his hands to minister to many people. This is not about me; it's about Christ in me, "the hope of glory" (Colossians 1:27). It's about the God-established process of training women—spiritual sisterhood. Older women, sister peers and spiritual daughters have all been critical in my development as a minister.

It is my belief that God has ordained woman-to-woman spiritual mentoring as the way to train female servants for ministry. I am not opposed to those who receive formal training for ministry via Bible school or seminary; but for the ma-

jority of women God has called to impact others, those are not viable options. God has not left us to fend on our own. He has established a way to mature and train us for the tasks he has called us to.

I'm not really different from other women. I'm a regular girl. What's the saying? I put on my slacks one leg at a time, like everyone else. In fact, all of us are to be ministers of reconciliation. Ministers are not a cut above others. Each of us is called to teach other women.

OUT OF THE RUT AND INTO DISCIPLESHIP

Discipleship is not just important for those who have a calling to public ministry; it is essential for all Christians to have in order to be who they were designed to be. I do not believe anyone can reach her full potential as a Christian without it. Everyone needs spiritual mothers, spiritual peers and spiritual daughters—in other words, older spiritual sisters, peer spiritual sisters and younger spiritual sisters.

If, as I gleaned from my informal polls, a large number of African American Christian females do not have the benefit of discipleship from a "mature" Christian woman, then the Christian community has suffered a large loss. Without discipleship of the majority of African American female Christians, it should come as no surprise that the majority of the people who make up African American churches have more than a few problems.

I'm not sure if our lack of attention to God's mandate on mentoring has to do with ignorance, rebellion or just being stuck in a rut. If we are in a rut with God, we need to get out of it. If we're stuck because another believer has done us wrong, betrayed us, lied about us or harmed us in some way, we need to get over it. And if we're thinking selfishly, thinking it's all about us, we need to get real with it. It's God's work; it's not

about us. We need to let go of our self-centered, it's-all-about-me perspective and understand that it's really all about him and his purposes.

Let's start out with you. Don't look around. I'm talking to you, the one reading this book. I have a question for you: do you have a spiritual mother in your life? I have another question: are you a spiritual mother to someone else? These are the two most important questions I could ask you. We can talk about the importance of having spiritual mothers in the 'hood. We can talk about the importance of mothers impacting the lives of younger women. That's all good. But the bottom line is, where are you and what are you doing? Are you a mother? Are you challenging, encouraging and helping one or more of your spiritual peers do the Titus 2:3 thing? Are you doing what mothers do and should be doing? If you are young in the Lord, are you being mothered? Ultimately, what's going to count when we face our Savior is whether we obeyed his mandate as mothers and daughters, both natural and spiritual.

Women come with various personalities, backgrounds and stories. Each of us is like a snowflake; no one else is like us. But we do have things in common. One is that we need each other if we are to survive. The song "I Need You to Survive" is so true. We cannot make it by ourselves.

As I write today, the first African American president of the United States is about to be sworn in, and our country faces many, many challenges. Unemployment is steadily rising. People have lost money in the stock market, and retirement funds have been wiped out. The economy is in an Intensive Care Unit, receiving care but not getting any better. People are despairing.

We all need others to come along beside us in these times. Discipleship is coming along beside an individual and showing her what it means to live as a Christian. Christian disciple-

ship is not attending church on Sunday mornings. It's not reading the Bible. It's not listening to tape series or television sermons. Spiritual mentoring is needed to help us make it through trying times.

Discipleship is how Jesus brought the kingdom of God into the earth. Thus it is the model for any and all ministry today that will have lasting effect. If there ever was a time when we needed to stand together and help each other based on the Word of God and prayer, it is now. These are exciting times. They are times when we will—with the help of God and each other—make it. But we will have to learn to depend on God, which is easier said than done. The title of the song "Learning How to Lean" says it all: we have to learn how to lean on God. This does not come naturally. Learning how to lean often means we get knocked around by the storms of life. And we can't learn how to lean without help.

WOMEN NEED WOMEN TEACHERS

We women can't rely just on pastors to give us the help we need in our growth as Christians. We can learn principles from the man at the podium, but we need more than principles to really live out our Christian walk. We can learn a lot about the Word of God from our pastor, but God has specifically laid down the way women are to be taught to live their everyday lives: by older women. Women can better teach other women how to love their husbands; to love their children; to be "discreet, chaste homemakers, good, obedient to their own husbands" (Titus 2:5). The Word of God says these areas are important so that his Word not be blasphemed. But women have to work through many struggles to be obedient to God. Guidance in this can best come from someone who is willing to get up close and personal.

Jesus tells us to make disciples by teaching the observation

of all things he commanded (Matthew 28:20). This clearly means taking someone under your wings and imparting knowledge—teaching her. It is not throwing some spiritual food out to everyone at once and expecting people to get fed. One-on-one teaching is key to the disciple-making process.

Jesus said, "Go therefore and make disciples of all the nations, baptizing them in the name of the Father and of the Son and of the Holy Spirit, teaching them to observe all things that I have commanded you; and lo, I am with you always, even to the end of the age" (Matthew 28:19-20). I'm going to go out on a limb and say that, regardless of the magnitude of the help we all have received from male ministers, there is something lacking if we do not have a spiritual mother. We can't be successful Christians if no one has taken the time to intentionally be a spiritual mother to us. We do have a heavenly Father whom we can go to in prayer, but without a spiritual mother, the task of maturing as a Christian woman will take longer and will be much harder. If every older woman in the church today took it upon herself to disciple just one younger woman, we would have a revolution.

> The point is what you are going to do with your life while living. You are here to glorify God, and God needs to take over your life.
>
> *Shermine Florence*

MENTORING IS A WIN-WIN

The times in which we live are challenging, and they can help all of us grow in our relationship with God. We have the privilege of sharing our opportunities of growth with others by encouraging one another, serving one another, spurring one another on to good works, loving one another—and all the one-another admonitions we have been asked to do as members

of the body of Christ. As sisters, no matter our age, we've got to reach out to others—and particularly to those who are younger. It's imperative! We've got to do it for the benefit of those coming behind us. We've got to do it for the health of this nation. We've got to do it for the sake of our walk with God and because of our love and our desire to obey him.

Wisdom plus energy is a winning combination. And the concept of two being better than one is truly demonstrated when you combine the wisdom of an older woman with the innovation and energy of a younger woman. Outside the marriage relationship, there may not be a better illustration of this concept than that of an older woman coming together with a younger woman in a spiritual-sisterhood relationship.

Two are better than one,
Because they have a good reward for their labor.
For if they fall, one will lift up his companion.
But woe to him who is alone when he falls,
For he has no one to help him up.
Again, if two lie down together, they will keep warm;
But how can one be warm alone?
Though one may be overpowered by another, two can
 withstand him.
And a threefold cord is not quickly broken.
 (Ecclesiastes 4:9-12)

Young women keep you fresh. The enthusiasm and excitement of a younger spiritual sister motivates me to keep on keeping on. I sometimes have the tendency to be discouraged, especially if I'm facing multiple challenges. At those times, it appears easier to just let go and disappear into oblivion than to continue to push forward.

I find the older I get, the more the downs tend to outweigh

the ups. There are more deaths in our lives as we get older, which can take an emotional toll on us. Then there are physical conditions in our bodies that can add to the discouragement. Trying to keep healthy involves lots more time and money than it used to.

When we were younger, our children tended to keep us young. Chasing them around, then driving them around, kept us occupied and energetic. When they become young adults, they don't need us as they did during those earlier years. Things are different.

During these times, mentoring a younger woman can be a welcome addition. The younger people God has brought into my life have helped me get on with the Father's business. One such person is Jasmine Bailey, one of my current mentees. True to younger people, Jasmine found me via the Internet. I'll let her tell it in her own words:

> I have prayed for a godly, wise, older woman to ask [to mentor me]; I have written letters and asked older women to disciple me, [I have] emailed, attended conferences, signed up for discipleship groups, attended small groups [all] with the hope of possibly having a "God-connect." My most recent experience led me to look online for mentors, and I came across Mrs. O's and Mrs. G's conference for mentoring. This led me to put my name on a list for when they would begin a discipleship group. Actually, this time, I was just curious about being in a group that specifically focused on the importance of discipleship. Many times the role of discipleship was not intentional but was something that I learned from observation.

After my friend Gina and I mentored Jasmine for about a year

in a group, Jasmine approached me in the fall of 2008 and informed me that she wanted to accompany me on my speaking engagements in 2009. She told me that she was prepared to pay her way to all of the out-of-town trips. Thus began a one-on-one mentoring relationship with Jasmine that continues to this day, though not with as much regularity.

Sometimes, a younger woman may want to be involved in a physical activity that would be good for you. For example, I'm not much of a sightseeing person, but when Jasmine goes with me on trips, she tends to want to see everything possible. I have gone along on journeys I would have never considered on my own.

Maybe because they haven't gone through as many disappointments and difficulties as we have, younger women tend to be more optimistic. That's a good thing to have around; it definitely adds years and energy to life. Even though we may have wisdom to give due to the extra years we have lived on this earth, younger women are definitely not the only ones benefiting from discipleship relationships.

Younger women also bring a fresh perspective to decisions and issues. They tend to be more open-minded. I find myself asking Jasmine, my daughter and other young people their opinion on a lot of things, because they have minds that are flexible and creative.

Young women keep you honest. There's nothing like younger people to keep you honest, sincere and authentic. They keep you on your toes. I'm not one who tries to put on airs or give people a false impression. Who I am is who you get. In dress and appearance, I'm plain and simple, and I like it that way. So it is not too difficult for me to be authentic. But boy, if I did a lot of pretending, I would not make it with young people.

The innate ability of younger women to make you more authentic is a good thing. The older we get, the more we tend to

have concerns about our worth and value in this world. This can make us prone to exaggeration and embellishment. Contrary to what we may think, young people want the facts. They like it straight.

Young people are tired of those who say one thing and do another. They like people who will say what needs to be said, no matter who might not like it. I struggle a lot with wanting people to like me, but I have to be more concerned with whether God likes me. It does no good to have everyone down here madly in love with me and get to heaven and find that God does not even know me. As Jesus said,

> Not everyone who says to Me, "Lord, Lord," shall enter the kingdom of heaven, but he who does the will of My Father in heaven. Many will say to Me in that day, "Lord, Lord, have we not prophesied in Your name, cast out demons in Your name, and done many wonders in Your name?" And then I will declare to them, "I never knew you; depart from Me, you who practice lawlessness!" (Matthew 7:21-23)

What a tragedy! I would not want that. So I have learned to overcome the fear of man by fearing God more, and younger women have helped me via their words and their example. The apostle Paul wrote to the Galatians that he could not be a servant of God if he still sought to please people: "For do I now persuade men, or God? Or do I seek to please men? For if I still pleased men, I would not be a bondservant of Christ" (1:10).

Young women bridge the generation gap. We might think that younger women do not have the time, tolerance or interest to get together with us. *They are into technology and the like. What do they want with an old fogey like me?* we may be tempted to

imagine. This attitude is as far from the truth as it can be. Let me be clear: young women are not going to be persuaded to do research in your set of encyclopedias when they are used to using the Internet, but many will value your wisdom. They want to learn from you. Let them.

There are things young women can do that will make your life easier. If they volunteer to help you, let them do so. Now, do not look at a relationship with a younger woman as a means to get chores, shopping and other things done. I'm just saying, if a younger person whom you are discipling offers to help you in a particular way, accept it graciously.

Young people ask good questions. I like questions. Questions make you think and keep your mind young and active. Questions help me question what I think. Some people run from questions because they don't want to have to say they don't know. They don't want to look dumb. But questions will actually make you smarter. I like people to ask me questions. If I don't know the answer, I can explore or look it up. That will make me smarter and keep my mind sharper.

─❦◦

When we invest time and energy into another's life, it just may turn out that we are receiving a benefit comparable with what we give out. I truly encourage older women to make investments into the lives of younger women. I would be amiss if I mentioned the benefits of investing in the lives of younger women as a means to motivate you to do so. The reason we mentor is because we are commanded to do so in Scripture.

The advantages of being a spiritual mother are just gravy; they are rewards for being obedient. Nevertheless, they can help us stick with the process when things get difficult.

WORDS OF WISDOM

When I did some leadership training a few years ago, Alice Pittman helped me by being one of the trainers. She and I have gotten together at her home, and she has hosted my husband and me at her home too. Here are some words of wisdom from her:

There are many things that I can say in reference to my walk in the Lord for more than forty-five years. I have experienced the importance of prayer, the study of the Word and the steadfastness of faith. However, as great and as powerful as they are in the life of a believer, there is nothing more powerful and assuring than knowing that God loves you and that He is trustworthy. There are times that your circumstances and emotions will cause you to question His love for you, but remember His love is unconditional. There will also be times that you will even question your love for Him. That's okay. For as sure as the sun rises in the east and sets in the west, God's love remains unconditional and steadfast for you. You can trust him because He is God and He loves you.

2

The Challenges and Triumphs of Mentoring

—⁘◦—

*M*yriad challenges face women who want to mentor and be mentored in an intensive, personal way. The challenges are real. They are substantial. They are inevitable, because women from different generations have to work at understanding each other. Each may have to make compromises, but the process of spiritual sisterhood will help each grow in her relationship with God.

But there are triumphs too—when a young woman finds a spiritual mother who helps her learn important life skills; when an older woman guides a younger spiritual sister through her turbulent teen years; when spiritual mothers live with integrity before their spiritual daughters.

THE GENERATION GAP

Potential mentors say things to me like this: "It's really difficult relating to younger women" and "I don't know any younger

women who would want me in their life." Yes, these are some significant challenges, but we have to be careful not to turn them into excuses, because younger women tell me this: "I can't find any older woman to disciple me" and "Most of the women at my church have families, jobs and church work. I would love to spend time with them; they are too busy to have time for me."

I decided to ask around to see if any older women had made serious attempts to pour into the life of a younger woman and had been discouraged with a lackadaisical response. I could not find many examples. On the other hand, I was able to locate more young women who sought to learn from older women but were disappointed with the lack of response they received.

I'm not saying that younger women do not spurn the help of older women. I'm sure there are many cases when that happens. But I would estimate that for every older woman who does not seem to be able to connect with younger women, there are probably more younger women who are having difficulty finding an older woman to mentor them.

I interviewed several young women on the subjects of finding a mentor and their experiences in being mentored. Some spoke of how they have mentored others. They also talked about the benefits of mentoring.

BRIDGING THE GAP

Morgan Blount, a friend of my daughter, Esohe, points out that the responsibility of intergenerational mentoring lies with both the older women called to mentor and the younger women who can benefit from the relationship.

> I do believe that we younger African American women should allow ourselves to learn from older African American women. I know from experience there is a lot to gain

from this. As younger women, we must respect where our elders have come from and what they have to offer. There is so much that we can take from them; even though their life experiences were different from ours, they have wisdom that we could never get on our own. Really, there should be mutual respect: our generation should humble ourselves to learn from and ask questions of the more mature generation, but the more mature women should respect us as well.

Sometimes pride may hold people back from pursuing other people to get what they need. At other times, it may be fear. We are afraid to approach younger women if we're older; we're afraid to approach older women if we're younger. We older women wonder if we can really pull it off. We wonder about whether we'll help them or hurt them. We are intimidated by the prospect of having to expose ourselves, warts and all.

To fear is human. To replace fear with faith is wise. To replace fear with love is the ultimate substitution: "There is no fear in love. But perfect love drives out fear. . . . He who fears has not been made perfect in love" (1 John 4:18). Let love be your motivation for mentoring—not fear of what will happen if you don't, but love for God's humanity that is so strong that it overwhelms all your fears.

SEARCHING FOR A MENTOR

Jasmine, whom you met in the last chapter, is thirty-two, and she told me first of her long search for a mentor:

> For as long as I could remember, I had a desire to learn from the older girls, women or people that I observed. I have gone different routes in achieving this: I have read about women in the Bible, tried to find women who reminded me of them and asked several ladies to mentor me

or disciple me. I have also tried the "silent method"; I would not ask for personal one-on-one discipleship but I observed the way many women interacted with their children, neighbors, spouse, themselves and God, and made mental notes of what I wanted to imitate. I also used this same observation to learn what I did not want to imitate and possibly to learn what to avoid.

Jasmine makes it clear that young people want older people in their lives. They are looking and praying and doing what they can to make it happen. As older women, let's make sure we make ourselves available as well.

LEARNING FROM A MENTOR

Eventually, Jasmine found an older woman who was willing to disciple her. They decided to focus on budgeting and staying on track financially. Jasmine says that she learned about how to deal with life situations from this mentor: "I really saw that I don't have to be an emotional wreck from situation to situation. Understanding that I did have control over how I responded to situations, people and circumstances caused me to see responsibility from a totally different perspective." She makes a point here about the nature of mentoring: it's not just about learning certain skills—it's about understanding how to face the world as a believer.

> We're here for him. He isn't here for us. Find out where you are in God's plan. God has a plan, and he put you in that plan. He's going to provide for you in that plan.
>
> Shermine Florence

My daughter, Esohe, who is twenty-five, describes what she has learned from her mentor. She also points out that God

brought this mentor to her after years of praying for one—at the time when she was ready for the commitment.

> One woman of God, who I will call Pastor T., is a woman of much wisdom and depth in the Word of God. She is an inspiration in many ways, and she speaks to me from years of experience and work in ministry.
>
> God has a way to get us what we need when we need it. In those years that I prayed for a mentor, I don't think I was truly ready for the commitment. If I didn't have a mentor these past two and a half years, I would not be the person that I am today. Pastor T. has been a lifeline for me, and I am learning to be the type of person who is able to be mentored and poured into. Mentoring relationships take time and energy from both parties. I've learned much and I have much more to learn. God is making sure that at every step of my life, I get the personal guidance and instruction that I need. I am learning that the type of relationship that I have with Pastor T. is really a major part of what life is about. The benefits of this mentoring relationship have been immeasurable.

MEN AND MENTORING

Jasmine mentioned that she has asked men to mentor her, but she would not do this again "unless I am being mentored by a couple or if it was in a professional setting such as a job coach or specific position that required the expertise of the male." She continues: "This is not to say that it is a bad idea. For me, I found that it can be an uncomfortable situation." She also explained that one male mentor had quit meeting with her because he was uncomfortable with what other people might think about their relationship, which was very disappointing to

her. But this is reality. We live in a fallen world, and male-female relationships, no matter how innocent they may be, are fraught with risks, not the least of which is other people's perceptions. Jasmine is wise to exercise caution in this regard.

GROUPS AND MENTORING

For three years, I discipled a group of women. In this group, I had to faced difficult situations, ones in which I truly did not know how to proceed. For example, two of the ladies did not get along. It was not pretty. I felt like a referee. It was very uncomfortable for me, but it forced me to grow in areas where I lacked. Discipleship can bring you to the end of your ropes, so I learned to lean on the power of prayer. Prayer is critical in any discipleship endeavor.

I was also at a loss when people became confrontational, argumentative and challenging to me. I'm a peace-loving person who tends to avoid conflict at all costs, so I was forced to grow in relationship skills. This was all good, but very uncomfortable while I was going through it.

I truly grew in my relationship with God, and I grew in the ability to love others. That's really what it is all about—learning to love God with all of our hearts, minds, soul and strength, and loving our neighbors as ourselves. The process of discipleship has enhanced the very core of my walk with the Lord.

THE TURBULENT TEENS

Mentoring can be very helpful to teenagers during their high school years. Esohe says,

> Through my high school years, the lady who mentored me served as my accountability partner. I used her as a sounding board when I went through the "stormy teenage" years.

When I wanted to do something that I knew I shouldn't do, I would tell her. I wasn't a troubled teen by any definition, and I didn't make a whole lot of bad decisions. But the ones that I did make, I knew that I had disappointed three parties: my parents, my grandmother (who I always knew was watching me from heaven) and the only other person who I really felt had a vested interest in my life—my mentor, Karen. That was my catalyst to do right.

Knowing that someone outside of my parents cared about me and how I matured made me want to avoid mistakes, and it kept me from going the way of the crowd. Karen wasn't afraid to be different; she didn't mind dancing to a different tune than others around her. She modeled before me and helped me live out the passage that states, "Enter through the narrow gate; for the gate is wide and the way is broad that leads to destruction, and there are many who enter through it. For the gate is small and the way is narrow that leads to life, and there are few who find it" (Matthew 7:13-14 NASB). Because of her role in my life, I knew that I didn't have to be like the other teens that I knew. I did not have to try to fit in to any mold.

Now, as an adult, Esohe works with teens herself, recognizing that young African American girls need to have the kind of relationship she had. She says, "There is an entire generation of young girls in my city that are going straight to destruction; who will show them the narrow gate?"

INTEGRITY IN MENTORING

Esohe also talks about the importance of integrity in mentoring relationships as she shares the influence of a second mentor:

When we have an opportunity to meet together, I always feel like I need to record every word that she says because she speaks directly into my life and she has revelation that is so practical and useful. I've had opportunities to go with her as she has spoken at different churches, and I've spent time with her around her family. I've seen her on the platform and in her living room. I've noticed that she is the same person through and through, no matter where she is or who her audience is. We've gone over the Word together and we've gone over my finances. She's prayed with me and she's prayed for me. All of these experiences have built a relationship that is continuing to grow and to stretch me in different ways.

Notice that Esohe says she has seen her mentor "on the platform and in her living room" and that this minister is the same person regardless of her environment or surroundings. It is extremely important, particularly with young people, that we as older mentors walk what we talk, that we have integrity. We let our young people down and we give them no place to turn when we preach Jesus on Sunday and at conferences but live Monday through Friday as if he were not around. I am grateful to these other women in my daughter's life who have shown her love but have also provided the most important thing: a good example.

> Don't try to hurry Him. His ways are not our ways. Don't jump ahead of Him.
>
> *Thelma Mason*

WE ALL HAVE SOMETHING TO OFFER

Recently, a young woman who had an infant baby wanted to get together with me to discuss how my husband and I were able to

raise what she considered to be three wonderful children. She said it; I didn't. In fact, I attempted to fix my mouth to argue with her that my three adult offspring were not wonderful, but I just could not do it. (Oh my, they say pride comes before a fall. *Thud!*) She proceeded to tell me that she knew a lot of young people who came from Christian homes who were not like my children. She considered my children to be strong, on-fire Christians.

I guess she figured my husband and I had some secret, and she wanted to know what it was so she could do a good job raising her baby girl, who was a real cutie, just a doll. Honestly, I do not think "the secret" has to do with my husband's and my actions. If I had to attribute the success of my offspring to anything, it would be to my grandparents on my dad's side and my mom and dad, who left a heritage of blessings to their offspring and to subsequent generations. My adult children have many cousins who are just like them. Just as curses tend to go on from generation to generation, so do blessings.

But, you know, this young woman's baby was so cute, and I was longing for grandkids myself. I thought, *If this is what it takes to be around that cute little girl—and that will help me wait until my own grandchildren come along—we should get together.* So I agreed to talk with her.

I needed a little time before we met because I had no idea what to tell her. I thought about her comments about my children, talked to one of my sons about it, and even asked God if there was anything that my husband and I had done that contributed to the fact that all our children love the Lord and serve him passionately.

That's when I realized that this young lady felt that I, as an older woman, could help her with the task she had before her of raising her children, *but I thought I had nothing to offer.* I remembered that is exactly what the apostle Paul said older women

should do: teach the younger women how to love their children
and how to love their husbands. Perhaps I could give her some
pointers, anyway. It goes without saying that no one is perfect. We mess up
when it comes to loving our children and loving our husband—
if we have children and a husband—but we can teach others
from all our successes and failures. As older or mature women,
we have learned from both mistakes and successes, so we can
teach younger women from the wealth of our experience as
well as from the most critical source, the Word of God.

I did get together and shared with this younger spiritual sis-
ter some of the things I felt may have made a difference in our
children's lives. In a nutshell, here they are:

• Consistently praying for our children that God's will, pur-
 pose and plan would be fulfilled in their lives. My husband
 and I prayed this *together*, not just individually. Praying indi-
 vidually is good, but praying together as parents is much
 more powerful (see Matthew 18:19).

• Being authentic in our relationship with God before our
 children.

• Allowing our children to make important decisions on their
 own in the safe context of our family. By the time our chil-
 dren were in high school, instead of buying their clothes for
 them and giving them money for lunch every day, we di-
 vided all those expenses for the whole school year by twelve
 and gave them a monthly allowance that they had to manage
 for clothes and lunch. They were responsible for spending
 their money wisely.

No matter what type of family we originated from, we each
can lay down a fresh heritage of blessing for the generations to
come. We all have something to offer, no matter if we are young

or old. And what you have to offer will be different from what I have to offer. I am referring to natural as well as spiritual generations here. In other words, you can lay a foundation for your children as a parent, and you can lay a foundation for others to whom God brings you as a mentor. Those of us with children and grandchildren need to be willing to share with others what worked and what did not work. Younger women need input from us. Some will ask. Others may want this, but may not know how to ask.

I don't know how much this young lady was able to garner from me that will help her in raising her daughter, but whatever the result, I needed to be faithful in doing what God had instructed me to do. If others ask, then I have no choice, because it is already a mandate.

BEYOND DISAPPOINTMENT

Younger women sometimes have a disappointing experience in a supposedly mentoring relationship with an older woman. One young woman told me she volunteered for an older woman, thinking she would be able to glean from her some things about the field she wanted to go into. The woman agreed to be her mentor. Unfortunately, mentoring did not take place. When the younger woman asked about it, the older woman responded that she had access to all her books. She also told her that the mentor wasn't the one who was supposed to call; the mentee should do that. These kinds of attitudes and situations make it more difficult for younger women to reach out to older women.

Younger women need the input of faithful older women so they can grow strong in the Lord. And they need to be proactive in seeking the impact of older women. Older women

need to mentor younger women, both because it's commanded and because it's a blessing. They need to be open to taking the risk to mentor. Older women need to be proactive and intentional about finding younger women they can mentor. It's not an option.

3

Who Is Qualified to Be a Mentor?

───❦───

I have been a Christian since I was five years old, and there have been times when an older woman has helped me with life issues more so than with spiritual issues. I have actually spiritually mentored women who were older than I, but that did not mean I could not learn from them. In fact, I have learned from most of those I have mentored, no matter their age. In order for a person to be one's spiritual mother, though, she should be more spiritually mature than the person she is mentoring.

Of course, if the older woman is not fully spiritually mature, then she should not be the mentee's *primary* mentor, but she may be able to contribute to a younger woman's life in an area in which she may have some expertise, such as cooking if she is an expert cook, parenting or marriage if she is a family- or marriage-relationship expert. But the woman who knows she has a lot more spiritual growing to do should be honest and

realistic when she gives input into younger women's lives. She should seek the counsel of a more spiritually mature woman.

Let's say than an older woman is a career counselor by profession—though this advice would also be true for people with different expertise, such as financial planning, parenting or marital relationships. This older woman may contribute to the lives of younger Christians in the area of career choices, but in giving counsel, she should give her advice from her professional point of view. This person should limit her counsel to her expertise and not try to pretend she knows about how God guides a person spiritually. Yet she could emphasize the role of prayer, and she may want to challenge herself to study the Scriptures for spiritual principles she can add to her counsel of young people. But she should mention that God's plans may not necessarily follow the way she has been trained, and she could remind the young people that there is safety in the multitude of counselors.

So who is a true "spiritual mother"? We should not take this term lightly. Is she "older" as it relates to chronological age or as it relates to maturity? Obviously, it's ideal if a woman who comes along beside a younger woman is both older and more spiritually mature. This woman is able to bring to the table what she has learned from life's experiences and what she has learned from the faith.

As I've asked the question, allow me to provide the answer: "Spiritual mother" refers to a mature woman who has acquired practical and spiritual wisdom, a woman who has the ability to give no-nonsense advice, a woman who has the ability to offer wisdom to other African American Christian women in a nurturing and caring way. Spiritual mothers are those who have lived life and know a little something-something. They have made their share of mistakes, and that makes their value that much more precious.

Also think about this: a younger woman can benefit from the experiences of a woman who is older chronologically, whether or not the older woman is spiritually mature as a Christian. This older woman can provide practical help and understanding to the younger woman regarding loving her husband and children. Obviously, if she is older in spiritual maturity, she can also provide the spiritual help the younger woman needs to grow in the faith and to learn from a spiritual standpoint how to be discreet, chaste, good and obedient.

THE YOUNGER CAN BE MENTORS TOO

But spiritual mothers need not be gray-haired and over sixty. A younger mature Christian—that is, one in her twenties or thirties—who became a Christian at an early age can have valuable wisdom to share with young girls or teenagers. To that younger generation, you may be the best "older" woman to relate to their particular needs and challenges.

You've already met my mentee, Jasmine. Here she tells how even she, as a relatively young woman in her thirties, found herself in the category of "older woman" to a younger Christian.

> Seek the Lord. Really seek him and be led by him and then study and be open and read different material. You need to be informed. You want to live a good life. You should start out early, and you should be teachable.
>
> *Clotee Ware*

I never considered myself a mentor to younger women. I often felt I was the younger woman needing mentoring. What's amazing is that younger women grow to become older women. Even though I am not what I consider to be older, I have "officially" crossed over to become older than

the twenty-something age range. It was pretty eye-opening when I began to live out what I preach. I have been involved with youth groups as an undershepherd. This was a youth leader who led a small group in a particular part of the Detroit area. I did not realize it at the time, but this was a major example of the importance of discipleship for me.

As an undershepherd, it was easy to get a mindset of "teaching these bad kids something good." As I looked closer and was in their world, what I saw was that my Monday-night "z-team" didn't mean zip in a world that they had to go back into and live. I began to see that the pressure of daily living without godly influence is great and that my "good deed" of leading wasn't much.

I have also connected with a friend of mine who was saved for the first time at nineteen years of age. She was a new Christian "on fire" for God. She really wanted to know Him, all about Him. We would meet and read the Bible, discuss what it meant and how we could apply it to our life. Sometimes we would get together and just hang out. But one thing that she always wanted to do was "have fun," and she began seeing that a lot of Christians weren't about having fun outside of going to church almost every day of the week and then some more.

I began dreaming up a place where young people could develop outside of their family and get to know God and grow in a practical way. This really came out of a desire to really grow and know the God that I'd been taught about my entire life.

Jasmine is a young woman, but she does not let that stop her. She desires to see others benefit from her own Christian experi-

ence. Her experience may be brief, but she still realizes that what she has learned is significant and bears sharing with others.

WHAT MAKES A MOTHER?

When I speak of "mothers," I am talking about a wide variety of women—and not just about women who have given physical birth. I'm talking about women who have a whole lot to offer because they really don't care what you think about them. They're not scared to say what's real and what's right. In other words, they are more concerned about what God thinks about them than what you or I think about them.

Spiritual moms come in all personalities and form all professions. They come in all shapes and sizes. Some are quiet. Some are talkative. Some are unassuming. Some are in-your-face. Some are nurses. Some are secretaries. Some are pastors' wives. Some are engineers. Some are teachers. Some are stay-at-home moms. Some are single moms. Some are single without children. Some are married without children. Some are . . . I'm sure you get the point.

Spiritual mothers are not perfect. It goes without saying that I am flawed. Recently, my husband expressed some heartfelt disappointments he had with me in an area that surprised me. (I already knew about the housekeeping.) I could have just thrown in the towel. I did think for a moment, *What business do I have writing this book on women loving their husbands if I haven't done a good job?*

Fortunately, perfection is not a requirement for discipling others. No one can say that they loved their husbands perfectly or raised their children without mistakes. We will also make mistakes in discipling others. That's just a fact.

Some people think that, because they don't have a Bible school degree or a lot of experience teaching the Word, they don't qualify for teaching younger women. Nowhere in the

Scriptures do we read of such criteria. To qualify, a woman needs to be

- a follower of Christ
- a more "mature" woman
- obedient

The Word tells us that if we love him, we obey his commandments (see John 14:15). We cannot claim to be his disciples if we are not obedient to his command to mentor. It does not take lots of money and it does not take a seminary education to be a mentor. It doesn't take membership in an exclusive club. Nor does it take skills that are out of reach or little known.

If it's not your season now to mentor, don't use that excuse forever. Look for ways to do it a little until you get to another season when your time is more freed up. Now that my husband and I are empty nesters, mentoring others is more doable now than when our children were younger. This is a different season of my life. I now have time to share with you, to motivate and encourage you to mentor other women, and perhaps even to help you do what God wants you to do.

WHO IS QUALIFIED TO BE A MENTOR?

Just because a person is mature in age does not mean she knows how to spiritually disciple a young woman. She needs to be trained by walking with the Lord herself. She needs to have a vibrant, ongoing relationship with God. She needs to be obedient in the things of the Lord. A woman whose walk with the Lord is not right may be tempted to give improper advice to younger women. Bad advice is sometimes given even from "seasoned" Christian women to younger women, as the following account reveals.

I want to share a not-so-good way to mentor. The Lord

was teaching me that it was possible for an elder to mentor out of her "fleshy ways" and not according to His Word, so I also had to use discernment. I am a single woman and have never been married. One of my older mentors one day told me it was okay for me to have sexual relations and the Lord would understand. She continued to try to encourage me that it would be okay. Something in my spirit did not feel right about that. I separated myself from this older lady, and I later found out she had been having a hidden affair for years, though she was a mother in the church and very active and never missed a revival.

A humble, honest and obedient woman. It appears to me that the older woman was giving that advice as a way to justify her own behavior. I would never justify blatant disobedience to God's Word, but we know we all have struggled with one area or another, at one time or another in our Christian walk. There is a difference between acknowledging our struggles and seeking help, and excusing our wrong and encouraging others to do the wrong as well. It is better to be honest and say, "I don't have everything together. I struggle in some areas." We don't even have to say which areas we struggle in. This older woman could have asked her mentee to keep her in her prayers. That would have been the honest thing to do. It is not right to tell younger people that they do not have to obey the Word of God. That is just wrong.

Thankfully, Melissa was grounded enough in the Word that she realized she was getting poisoned and was able to move away from the source. Fortunately, she also has had good disciplers in her life. If we are to be spiritual mentors, we must be obedient to the Word ourselves. It is crucial that a woman be as faithful as she can be in the things of God.

I'm not saying we need to be perfect, but we do need to be honest and biblical. For example, I have struggled off and on with my weight: I put on fifteen pounds after the death of every important person in my life, including my mother, my sister and my father. God forbid someone else dies! Though I have challenges with grief that affect my weight, I don't teach that it does not matter how we treat our bodies. I acknowledge my own personal struggles. And I am beginning to go in the other direction.

> When you face death, your priorities change. You don't have to wait until you face death; you can change your priorities now. What is really a priority? Is this really important to my glorifying God? If it isn't, get rid of it.
>
> Shermine Florence

It helps others when you are able to admit your weakness. Seek God's help in your struggles and allow those you disciple to know about your wrestling with God in these issues. A spiritual mom needs to be teachable. She needs not to concern herself with someone seeing her weaknesses and inadequacies. She needs to get over herself. Young people can smell a phony a mile off.

A woman of the Word. The woman who disciples must have knowledge of the Word of God. However, if she does not have the knowledge she thinks she should have, she can be working on it as she is discipling a younger person. She can study enough to stay one step ahead.

My sister-friend Victoria Johnson is a Bible study guru. Here are her thoughts about knowledge of the Bible in the discipleship process, from her book *The Sisters' Guide to In-Depth Bible Study:*

> One of the reasons younger women say they don't want to listen to older women or sit under them is because

they often "shoot from the hip." I remember listening to an older saint say, "Women have to keep themselves pure but men—you can't expect that out of them." I challenged her. "Where is the Scripture and verse for that?" I asked. She told me some things are common sense and not in the Bible. I knew to stay away from her and her advice.

But not Ms. Smith. She made the gospel crystal clear to me and always used the Bible to answer my questions. This made me curious about the Bible. If you want to be a mentor, you simply have to base your counsel on the Word of God. There is no excuse for not knowing.

A woman of virtue. Victoria has also told me how to determine whether an older woman can really be a good mentor, saying:

According to Titus 2:3, the qualifications for spiritual mothers include reverence, avoidance of slanderous words, no alcohol abuse and the ability to teach well. The mature woman is to help the younger women, teaching them how to love their husbands, how to love their children, how to be discreet, how to be homemakers, good and obedient to their own husbands.

And she has shared a multiplicity of New Testament verses on mentoring. Maybe they don't say the word *mentor*, but we can glean much on mentoring from these verses about spiritual maturity and the responsibilities of older Christians toward those younger in the faith:

According to Colossians 4:12, the spiritual mother should pray for her mentee and teach her the Word. As with any relationship among Christians, the spiritual mother is to

be transparent and honest (James 5:16, 1 Peter 2:1, 12). The spiritual mother should also take the initiative in reaching out to younger women (Luke 6:12-13).

—⟩⟨∘

Sisters, let's be mentoring. If you are at least in your twenties and have been a Christian for at least five years, there is much you can contribute to those who are younger. It does not matter if you have made all the right choices. It does not matter if you have all the answers. What matters is a willingness to invest in the lives of women who are physically and spiritually younger than you. Join the many others who have benefited from the process of disciple-making.

4

How to Find a Mentor

—⟨⟩—

\mathcal{I}t wasn't easy finding someone to disciple me one-on-one. The closest spiritual mentor I'd ever had was my own mother, Shermine Florence. She lived out God's idea of mentoring, and because of her rich devotional life, she was able to do it God's way.

Even though the Lord blessed me with Mom as well as many others who were models and examples of godly women, I still felt I needed someone to take me "under her wings." There is a commercial in the Detroit area that shows some chips in a casino saying, "Pick me. Pick me." The commercial reminds me of myself when I was in my early twenties; I wanted someone to pick me as someone she would disciple. Mind you, I didn't ask anyone. I just went around hoping someone would offer to disciple me—a young adult seeking to be mentored in speaking and writing ministry.

HOW I FOUND A MENTOR

When I was in my twenties, I approached a national speaker and asked for help. She told me to buy her books and tapes. At

the time, I was offended, but I really should not have been. This woman did not know me. I did not live anywhere close to her. What else would you tell a complete stranger? But I had invested time, energy and money to drive halfway across the country to listen to her; surely she could spare a few minutes and give me some tips, ask for my telephone number, ask me a few questions—just offer some help. That experience made me a little gun-shy. I continued to ache for an older woman in my life, but kept expecting someone to spot me and come up to me to ask me if she could mentor me. Well, that did not happen.

Then God impressed on me to be proactive again, but on a realistic level, by approaching people with whom I already had a relationship. I actually met one of my current mentors, Clotee Ware, before I moved to Detroit. Her daughter Andrell and I knew each other in Chicago before either of us was married. We attended the same church right after I got out of college. When Andrell moved back to Detroit after marrying a young man from there in the early 1980s, my husband and I drove to Detroit to attend her wedding, and we ended up staying at her parents' house. After my family moved to Detroit in the late 1980s, I became reacquainted with Sister Clotee Ware. She was an older woman. She was a pastor's wife. She was involved in ministering to children in the Boys and Girls Bible Club. And overall, she was a warm and gracious woman. She wasn't a national speaker. Neither was she a writer. But she was open to forming a mentoring relationship with me. She was one of the older women God had for me, and I am so grateful that I did not limit myself to the kind of person I thought I needed.

Clotee and I pray together every Monday morning. She is caring and a true spiritual mom. I can share intimate prayer requests with Mother Ware. And I'm not the only one; she actually prays with many other women besides me. Six days

of the week she's praying with someone, sometimes twice in one day. It may be with someone older than she, someone younger or someone around her age. These are examples of spiritual sisterhood.

Mother Ware uses the avenue of prayer to impact the lives of others. She told me that, at times, she gives counsel during a prayer time. I know she has often shared Scriptures with me and has helped me over a few humps during the time we have been praying together. Mother Ware also teaches a class on Mondays in her home. At her church, she teaches two classes a week.

There have been other mothers in my life as well. I was involved in different events and venues with the late Malettor Cross, who with her husband established Detroit's Afro-American Mission, and I gained insight and wisdom from her. Though I would not say I had a one-on-one discipleship relationship with her, I did go to classes or events she was involved with or sponsored. Once she taught a sewing class, and I *almost* enrolled in it, even though sewing is not something I enjoy! I would stay in touch with her over the phone. When she taught a workshop at a conference, I would usually choose to sit in just to gain insight from her, even if I was more interested in the topic of some other workshop. She was a blessing in my life, even from a distance.

> I have eleven children, a husband, and I minister to other people. Only trusting in the Lord and not feelings carried me through all of my many trials and tribulations.
>
> *Malettor Cross*

Similarly, Detroit native Alice Pittman, a retired administrative assistant in her mid-sixties, is one of the active moms in my life—even chiding me when I don't keep in touch with her as I should. Alice and her husband, James, have been church

planters but now pastor a church in Windsor, Canada, where they currently live. She is the mother of three adult children and the grandmother of five. She loves ministering the Word and says her favorite platform is her kitchen table.

Alice, however, is also a conference speaker, and I met her when I heard her speak at a women's conference. I had the opportunity to hear a recorded message she gave, which greatly ministered to me, but it also spoke to some things my own mother was going through in her life. So I sent the recorded tape to my mother, who also just loved it and was really blessed by it. Because my mother wanted to know more about this Alice Pittman, I tried to help her out and, in the process, got a chance to know Alice myself.

THE TABLES HAVE TURNED

It's been a few decades since I was in my early twenties, waiting for someone to pick me. And as the decades have come and gone, I've looked in the mirror and realized that I am now the older woman. I now have an obligation to be a spiritual mother, according to Paul. I need to be mentoring others.

My friend Marjory and her husband are missionaries in South Africa, and I have had the privilege of pouring into the life of Marjory's daughter Dawn for a time. Dawn, her daughter and I used to meet together at least every month, and we spent a lot of time walking around a park and sharing with each other. We have not had a chance to get together much since she married, but having just attended a baby shower for her second child, I suspect I will be a part of her life as long as we both live.

A few years ago, I also spent three years discipling a group of women. We studied *Breaking Free,* a book by Beth Moore, and my own book *Movin' On Up* as well as other Bible studies. Over

three years, at least sixteen women joined us, although no more than twelve were involved at any one time. All sixteen are living vibrant Christian lives. Eight have their own ministries or are involved in leadership roles in a local ministry.

CONNECTING WITH A POTENTIAL MENTOR

If you are a younger woman who wants the involvement of a spiritual mom, a few things will be helpful to you in finding that woman. If you truly want an older woman in your life, you already have a head start. Many women do not know they need this and consequently do not desire it.

Rhonda Smith, a mentor who currently mentors five women, actually found *me* as a mentor. She heard me speak, and I mentioned that I was mentoring a group of ladies, so she contacted me to ask if she could be in my group. Since the time Rhonda joined the group, I have seen her, her family and her ministry grow. Here is her advice to younger women who want to find mentors:

> First, I would tell them to pray for God's direction. Second, I would say they should observe women who seem to exhibit the Titus 2 qualities; look for women in places where you can observe them consistently (for example, at church or Bible study). Third, I would tell them to approach the woman to inquire about discipleship (send a letter or set a lunch meeting for the inquiry).

I believe it is important to look for a mentor close to home at first. That woman you're looking for may be an aunt; she may even be your own mother. Maybe you still have the chance to sit down and talk to your own mother or a spiritual mother in your church or city. If you do, don't waste any more time—call her and make the time to get together.

Ask her questions: How did you handle the birth of your first

child? Did you ever think about leaving your husband? How do you balance job and home?

Spend time with her. Sit in on a Bible study she leads. Go out with her on shut-in visits. Sit in her home or, even better, help her clean her house. Find out how she spends her days and how she "orders her steps." Those precious times will be with you for the rest of your life.

Now, I did have a great mother, one whom others wanted to be in relationship with. I'm not sure if I knew what a jewel I had when I had her; she was an excellent model. But I think it is always good to have someone who is not related to you as a mentor too, someone who can have different input in your life. Look for things you have in common with that woman. Maybe you both like to read, shop or bowl. Grab on to the commonality, and milk it. Take your possible mentor to the library, the shopping mall or the bowling alley; take advantage of whatever you have in common.

Also, look for a woman who seems to be drawn to you. Maybe she asks about your children or your husband when she doesn't see him with you one Sunday in church. That means she is interested. You can make the next move.

Find ways to help your potential mentor. An older woman may have transportation needs. She may need help with things around the house. Volunteer to help her. Although I don't advocate that older women expect such help from younger women, there is no problem with a younger woman offering help if she wants to. It's an excellent way for a spiritual mother to spend time with her spiritual daughter.

While you're looking for an older woman to be involved in your life, you certainly need to be praying. Your mentor may come out of nowhere. She may be someone you meet on the bus or at the grocery store. You had been looking all around at your church, but this person God had for you didn't even go to your

church. God is full of surprises. Don't even try to figure him out. He'll come up with the unexpected in a minute.

HOW TO FIND SOMEONE TO MENTOR

Now for the spiritual mom. Start out by expressing interest in the young lady. Pray for her even before approaching her. Make an offer to mentor her, or just begin to spend time with her without an official "I'm your mentor." It's important to go slowly. You can offer to study the Bible with her. You can offer friendship. Be genuine; don't make her your project. Learn about the culture of the age group she is in, such as Generation Y or X. Of course, learn about her as a person. What is her background? What does she enjoy and dislike? What aspirations does she have? What are her challenges? And whatever you do, let love be the guide.

> Love suffers long and is kind; love does not envy; love does not parade itself, is not puffed up; does not behave rudely, does not seek its own, is not provoked, thinks no evil; does not rejoice in iniquity, but rejoices in the truth; bears all things, believes all things, hopes all things, endures all things. (1 Corinthians 13:4-7)

If you find a younger woman whom you think is a good fit, persist in the pursuit as long as God gives you grace. Move on when God says to do so. If you have prayed, reached out and extended yourself, pray some more. If things still don't seem to work out for the two of you, move on. Don't get stuck. Obviously, this is not the right person, or maybe it is not the right time. There will be someone else. If it is very clear she does not want a mentoring relationship with you but God has put her on your heart, your assignment might just be to pray for her.

However, don't give up easily. Sometimes it may not work out

because the enemy sees what good may come of the relation-
ship and wants to thwart it. At this point, you might add fasting
to your prayer.

~❀◑

Now we're going to hear how two discipleship relationships
started: one is a recent story in which an older woman stuck
with a troubled young lady, and the other is an ancient story in
which a young woman pursued an older one, even to the point
of leaving her own people.

AN OLDER WOMAN PERSISTS

In this first story, the relationship started more than twenty
years ago. Even though the younger in the pair initially did not
desire a discipleship relationship, today she is grateful that
Jeanne Johnson was obedient to the Word of God. Jeanne writes
about their story:

> I met Alice through my son, who is an attorney. She was a
> witness to a case. She was very noncompliant. Later I saw
> her at my job. She was doing community service. She lives
> two blocks from me. I offered her rides home. Finally she
> consented for me to take her home. I would always talk to
> her about the Lord. She was such a good worker that my
> boss tried to keep her there with us, even though there
> came a time she had to spend time in prison. My boss kept
> her place.
>
> I would write to her in prison, and she would write me
> back. To be honest with you, I don't know why I was so
> insistent. It was limited conversation, but somehow I
> clicked with her. She was at a halfway house a few blocks
> from me. At that time she was in her late twenties. She had

had a child when she was fourteen. I talked to her just like I would talk to my daughters.

Finally she told me she was going to church. I didn't ask her to come to my church. What I understand is that you don't push people. She was really disillusioned with her church (ministers sleeping around). We older women at my job took her under our wings. I told her that she should really come to the United Conference for Women. She said what impressed her [at the conference] was when someone said, "Forget about the people you think should be here; you're here." She went forward for counseling. She started to receive literature, and she would call me about it. Her life did a 180-degree turn.

One time I was going to California for vacation, and I left her my car. She said no one had ever done anything like that for her. When I look at it, she was one of the young ladies with whom you see the fruit of your labor. I'm glad the Lord had me to be relentless. She told me the more she tried to get away from me the more I was there. She has respect for me. A lot of times when she calls me, she calls me before she calls her pastor. She told me I seem to know more than her pastor.

I bought her Bibles and Bible tools and taught her how to use concordances and how to study. She said, "You are what you are. You are always the same." I can call her at any time and ask her to do something; it'll get done.

A YOUNGER WOMAN PERSISTS

The book of Ruth provides us with insight on how older and younger women can connect. Younger women, consider her story: Ruth lost her husband, Naomi's son, at the same time that

Naomi lost her own husband. Ruth would have been fully within her rights to return to her familiar homeland, but she intentionally turned away from that opportunity in order to follow Naomi, a believer in the one true God. Four times Naomi entreated her daughter-in-law, Ruth, to return to her homeland. Each time Ruth insisted on staying with Naomi. The final time she replied with what is now a well-known passage of Scripture, "Wither thou goest, I will go; and where thou lodgest, I will lodge: thy people shall be my people, and thy God my God" (Ruth 1:16 KJV). Ruth did this at great cost. She risked never being able to marry and have a family, because she did not know how she would be received by Hebrews, whose customs and ways were foreign to her.

Your story may not be Ruth's. But the principles are worthy of our attention. Ruth was a woman who did not seek her own selfish ends. She made a conscious decision to follow God instead of an opportunistic decision to serve her own needs and desires. She had goals and aspirations that went beyond what she could see. She followed a woman whose lifestyle and heart she obviously admired, a woman who believed in the one true God. Ruth saw something in Naomi that was apparently irresistible, and she simply could not imagine her life without her beloved mother-in-law. She made the first, brave move to leave her country and kindred for a life that transcended land and blood relations.

And she was rewarded for her efforts with a kind, loving husband and children, and ultimately with a name and reputation that would live for centuries after her death, as she became a part of the lineage of Jesus Christ.

Talk about connecting! Ruth connected herself to Naomi, and God connected with Ruth for eternity.

5

How to Mentor

—⦇◈⦈◎

There is no one way to "do" spiritual mentoring. Some women have group Bible studies in their homes or in the church. The best of these more formal sessions allows time for women to share their daily struggles and victories with one another. That way, the teacher is not the only "mentor"; each woman has an opportunity to share valuable insights from her life. On the other hand, one-on-one mentoring allows the one being mentored to experience unique help. It allows the mentor to get to know the mentee in a deeper way. Prayer, counseling and even the topic of Bible study can be customized for the mentee's individual needs.

MENTORING: PLANNED OR UNPLANNED?

Sometimes the best mentoring is spontaneous rather than intentional and planned. In 2008, I spoke at a conference and was invited to one of the attendee's rooms at lunch break. There were women in the room ranging in age from thirties to late

seventies. Jasmine, one of my mentees, was traveling with me, and she accompanied me to the room. It was such a rich experience—informal, but truly a time when older women poured into the lives of younger women.

Let me have Jasmine tell it in her own words:

It was just an ordinary lunch at a woman's conference—or so we thought. We had pizza and fried chicken delivered to our suite-like room. It was January in Michigan, a cold wintry day, but the warmth of the Holy Spirit would soon descend and chase away the chill. I did not expect the treat that I received in that hotel room.

The most powerful aspect of group mentoring is the group dynamic. The woman, or women, being mentored can learn, grow and heal from the very real, very human stories that get shared. The honesty is contagious, and the impact can be significant.

The hostess for the conference and other attendees were getting together to talk and eat in one of their rooms. What made a lasting impression on me was listening to women who were in their fifties, sixties, seventies, and one was in her eighties (I believe). I heard this woman say that she still had a long way to go in her walk with Christ. He was still showing her things that needed to be changed to look like Him. I think that she had to deal with the fact that she was the one in her life that made things "happen." She shared that she realized the message from the morning workshop was calling her to give up the SBW (strong black woman) title. She had to make a choice.

Jasmine got to see someone in the throes of a spiritual transformation—almost right before her very eyes. She was blessed to see a woman struggle with herself in real time.

This woman, who was well into her way of doing things, realized that she had to change her way of thinking. Her desire to please God was stronger than her years of doing things her way. I didn't see a super-spiritual façade. What I noticed was a woman who was still willing to be molded into what God wanted her to be.

This experience caused me to realize that my plans of "arriving" would never come on this side of life. It also gave me hope to see that it is possible to change even my "set" ways of doing things. Although the choice was simple, it is far from easy. That day, I took away with me that it is worth the work to be the woman God wants me to be.

The time in that hotel room had a profound effect on Jasmine. But no one got up that morning and planned to impact a younger woman that day.

These serendipitous meetings are good, but we need to plan times of intentional spiritual mentoring as well. It could be a scheduled meeting at a conference. Or perhaps after church, we invite younger spiritual sisters over for an informal potluck with the thought in mind to pour into their lives. When discipleship is intentional, many lives are enriched. Then the unplanned times will be gravy.

When my niece lived with us, one of the ladies at the church we attended felt led to be involved in the life of the young women there. She began to pay them attention, inviting them over to her home to have Bible study with them. That's what I'm talking about. As older women, we have to intentionally pour into the lives of younger women.

TIPS FROM AN ELDER SISTER

Clotee Ware is an intentional mentor. At seventy-seven years of

If you are young and are thinking of getting married one day, don't be so anxious that you don't observe the person, listen to him, watch character. Note how he carries himself and how he treats you and how he treats other people.

Clotee Ware

age, she is a pastor's wife and raised her children as a stay-at-home mom. From the beginning, Sister Ware reached out to me. She is one of those women who can ask you personal questions and you're not offended, because you know she is asking because she genuinely cares about your well-being. She has a gaze that is direct and transparent, yet kind and loving at the same time. Here are her words of wisdom:

Seek the Lord, really seek him and be led by him, and then study and be open and read different material. You need to be informed. You want to live a good life. You should be teachable.

To be a good mentor, you have to be a good listener—to your younger mentees, definitely, but also to the leadership of your church. Sometimes we go to church and don't listen. I look at my life, and I could have done it better if I would have listened. Get good advice. Be teachable. We also need to fellowship with other believers. They can encourage you. It's important.

Sister Ware also says she used to give out advice freely, but now she prays more to hear what God might be saying. She believes it's important for women to be teachable and open to hear from someone else. She really wants what God has for her, so she is more mindful that her words represent salt and light.

The verse that guides Sister Ware and her husband is Psalm 71:18: "Now also when I am old and grayheaded, O God, do not

forsake me, until I declare Your strength to this generation, Your power to everyone who is to come." What a great verse to demonstrate the heart of an intentional mentor—the heart of a person who entreats God to let her declare his strength to the next generation. That is the heart of Clotee Ware, and that is why she is my mentor.

Sister Ware ends her words of wisdom with Psalm 1. Of course she uses *woman* in place of *man*, but we'll keep it as it is in the Bible.

Blessed is the man
Who walks not in the counsel of the ungodly,
Nor stands in the path of sinners,
Nor sits in the seat of the scornful;
But his delight is in the law of the LORD,
And in His law he meditates day and night.
He shall be like a tree
Planted by the rivers of water,
That brings forth its fruit in its season,
Whose leaf also shall not wither;
And whatever he does shall prosper.
The ungodly are not so,
But are like the chaff which the wind drives away.
Therefore the ungodly shall not stand in the judgment,
Nor sinners in the congregation of the righteous.
For the LORD knows the way of the righteous,
But the way of the ungodly shall perish.

MENTORING IS HOLISTIC

Mentoring is more than having Bible studies with your young charges. Melissa Jones of Honeybee Ministries tells what a mentor did for her:

One of my favorite mentors was Ms. Sylvia. I will never forget her. She taught me how to crochet and macramé; she also taught me how to make rugs. She saw my hidden gifts and *always* encouraged me in those areas. She knew I love to read, so she was always giving me a book to read. She saw my drawing abilities so she was always encouraging me in the arts. Ms. Sylvia was always introducing me to new things, new meals. I remember I had never heard of Brussels sprouts, though I loved cabbage. Once she found that out, she made me Brussels sprouts, and I love them to this day.

Recently Jasmine asked if she could come by my house to hang out. I knew what hanging out would mean to the friends in my age range. I just didn't know what it meant to someone twenty-something years my junior. I had heard her say she didn't like games or movies, so those two things were out.

Turns out, we just spent time together. We went out to pick up something to eat, brought it back, and talked, laughed and shared over the dining-room table.

It's been over a year now since Jasmine first asked if she could help me with my speaking. I believe her life has been enriched. I know mine has. In the meantime, she has lost her father, and she has finished school. I've finished a graduate certificate program. We've had numerous times of laughing, talking and eating together.

IT TAKES A VILLAGE

It has been said that "it takes a village to raise a child." This often refers to aunts, uncles, grandparents and even neighbors who participate in watching, feeding and disciplining a child. In like manner, it takes a variety of women to bring a Christian into maturity.

Latitia Watkins was a young lady that I attended church with at one time. She is now a codirector of a discipleship ministry at a church in Detroit. Her story is one of discipleship done the right way in a number of different ways. Her first discipleship experience came right after she became a Christian—the ideal time to be discipled.

Several people participated in Latitia's process of being brought to maturity. In fact, she is soon going to be celebrating her fiftieth birthday with a party, and she is inviting fifty women who have made her who she is. Now, that's a village!

One of the fifty, the second person who discipled Latitia, is Roberta Cross, wife of Haman Cross Jr., the pastor of Rosedale Baptist Church in Detroit.

When Roberta set out to disciple a group of twelve women, she set an example for pastors' wives to follow. I do not know many pastors' wives who take the time to disciple others. With all of the other obligations a pastor's wife has, I'm sure leading such a group is not easy. But good for you if you are a pastor's wife and are obeying God's mandate to disciple other women.

Latitia was one of the sixteen women who were a part of the discipleship group I did out of my home for three years. She also attended sessions I taught on prayer in my living room. I got my invitation to her fiftieth birthday party—fifty years, fifty women. And I thanked God I was able to have a part in her life.

I found out later that Latitia was a "discipleship granddaughter" of my friend Victoria: Victoria discipled Renee Carter at the University of Michigan, and Renee Carter was the person who was responsible for leading Latitia to the Lord and was her first spiritual mentor. It is wonderful when the process of discipleship goes on from spiritual generation to spiritual generation. That's what the apostle Paul tells us to do: "You therefore, my son, be strong in the grace that is in Christ Jesus. And the things

that you have heard from me among many witnesses, commit these to faithful men who will be able to teach others also" (2 Timothy 2:1-2). Here we see four generations of discipleship. Paul was one level. He taught Timothy—the second level. Timothy was to commit what he knew to faithful men—the third level. Then these faithful men were to teach others. It should keep going on and on and on, like the Energizer bunny. It is never supposed to stop as long as people keep being born and being born again. Though it is not mentioned in this passage, we also know Timothy's mother and grandmother influenced his life as a believer (see 2 Timothy 1:5).

Latitia says Renee Carter, her first mentor, really made an impact on her life.

I learned the basics of living the Christian life from Renee, and more importantly I learned the necessity of spending time with the Lord and in His Word. Her encouraging talks soon moved to one-on-one Bible study and eventually to a group Bible study with me and two other ladies for about two years. During that time she taught us, challenged us, prayed for us and, most of all, modeled for us a woman of God. Her love and reverence for the Lord was evident, and her respect and reverence for her husband was also amazing to me. I had never witnessed a marriage relationship based on the Word of God.

After this intense experience, Latitia went into a more formal, church-based program, where she got more specific instruction from Roberta, mentioned earlier:

Approximately three years into my Christian walk, I entered into a discipleship program at my church. The first lady of the church selected twelve women that she disci-

pled for three years. My knowledge of the Word increased tremendously as I received a deeper understanding of what it really means to crucify the flesh and surrender your life to the Lord. As I began to discover my spiritual gifts and ministry callings, I was blessed with a spiritual mentor. She helped me to understand and develop as an intercessor. I learned more about prayer, intercession and the connection between praying and God's Word.

It took all three of these women—Renee Carter, Roberta Cross and me—to make Latitia the woman of God she is today:

The prayers, lessons, love and most of all their examples are invaluable. As a result of their being obedient to the Word and pouring their lives into me, I feel obligated to do likewise. Therefore I am committed to carry out Matthew 28:19: "Go therefore and make disciples of all nations, baptizing them in the name of the Father and the Son and the Holy Spirit, teaching them to observe all things that I have commanded you; and lo, I am with you always even to the end of age." It has been a privilege and a blessing pouring into the lives of many young Christians through discipleship and mentoring over the past ten years.

It took three women inputting different things for Latitia to become the woman of God she has become; spiritual mothering has been responsible for training Latitia for her ministry calling. And Latitia senses a need to "teach others also." I like that.

RENEE'S STORY

Renee has been on both sides of the discipleship process. She has been discipled and has served as a discipler. She is in charge of the discipleship process at her church, where Latitia is a member. Her story is yet another example of the "village" con-

cept in discipling. (See appendix B for information regarding the discipleship program at her church.)

As Renee will tell you, she was a bit on the wild side. But that doesn't matter. When two are in his will and way, they can have a powerful impact. After all, "how should one chase a thousand and two put ten thousand to flight unless their Rock had sold them, and the Lord has surrendered them?" (Deuteronomy 32:30). Think how much more three or more can have on one woman's life.

Here is Renee's story:

I always wanted a discipler, a woman that was mature, to walk with me until Christ was formed in me. It took me years before I actually identified someone to "take me on." I was something of a wild child, and besides that, I seemed to repel women like chores repel teenagers. For example, I remember an encounter with one of my youth workers and his girlfriend. It happened at church on the occasion of my sixteenth birthday. The youth worker approached me to give me well wishes and a hug. Moments later, I could hear his girlfriend screaming at him, hurling accusations of impropriety. She blazed past me, flashing a look of sheer hatred as she ran out of the building. My youth pastor, who was standing next to me when all of this transpired, remarked, "Why do women seem to dislike you so much?"

Flash forward twenty-two years, and I am now a women's pastor. When given the opportunity to accept this role at Evangel Ministries, my current church where I have served for the last eight years, I recalled that moment and many others since and thought to myself, "But women don't like me, Lord. How am I going to lead them?"

Renee shares this anecdote to make a point about women and their impact on other women:

I believe that my experience with women is not a foreign or unique one. Women have a way of being the greatest source of support and friendship. Conversely, they can also be experts at jealousy, insecurity, betrayal and deception. It's no wonder that discipleship and mentorship among women is not extremely common in today's society or the church.

Renee's first discipleship relationship was informal, which seems to be an effective way for a young woman to "walk" into the world of mentoring and discipleship.

Despite the obstacles to discipleship, I have found my personal disciplers and mentors, and they have empowered me to become a mature, loving minister, wife and mother. My first discipler was my cousin Diane Reeder, a public relations entrepreneur, author and mother of two. She helped me prioritize and practice seeking out the voice of God through a disciplined devotional life.

She then got more directed instruction from a woman who had already walked in her shoes: "Pastor Alice Pittman then stepped in to aid me in my process of becoming a women's pastor. She was there to confirm my ordination."

Then Renee had yet another discipler—a man. Being discipled by a man is ground that must be walked extremely carefully, but it can work when both parties are solid in their walk with the Lord and accountable. "My senior pastor, Christopher W. Brooks, has been my discipler since 2001," Renee says, "and has challenged so many areas of my life that I cannot even begin to tell you about the benefits therein."

Finally, Renee gives honor to her husband: "My husband, Phil, has truly been the priest of our home and my heart for twenty years of marriage, and he consistently challenges me to mature and grow in Christ."

A "VILLAGE" IN A HOME

Just as a house of worship is one of the natural places where discipleship takes place, so is a home. As a matter of fact, spiritual mothering begins in the home. Mothers, grandmothers, aunts and older sisters can have a great impact on younger women in their families.

> For women and particularly moms, the number-one career is rearing the family. As mothers, we can instill Christian values in our children.
>
> Denise Lacey

Victoria Johnson is a product of generations of discipleship, and she continues it with her daughters. Here is her story and admonition to all of us:

Growing up, everywhere I looked I saw women who loved me. My mother, sisters, aunties, great aunties, grandmothers and great grandmothers surrounded me with words of encouragement. The color of my skin, the texture of my hair, my gifts, skills—all affirmed by one or the other. By the time I truly understood the technicalities and process of discipleship in my early twenties, I realized that I'd been discipled all my life. Then to add icing on the cake, when I became a Christian, God placed in my path several spiritual moms, sisters and friends. I've said more than once, I may not be a millionaire financially but when it comes to the people in my life—I'm a million-dollar lady.

SOMEONE TO "FUSS"

Many women in Victoria's life were not necessarily relatives or women's pastors or ordained ministers—just godly women who cared what happened to God's people and were willing to reach out and teach another along the way.

Mrs. Elsie Smith, my spiritual mom who led me to the Lord, took discipleship very seriously. She inspired my interest in the Bible. Whenever I asked a question, she would pull out the Scriptures and show me God had an answer for everything. Early in my Christian walk, she fussed at me and prayed over me. Still to this day, over thirty years later, Ms. Smith calls to check on me.

Every woman needs someone to "fuss" over them. If you're discipling a woman, or thinking about it, don't be shy about becoming a mother hen that clucks and flutters and fusses over her brood. As you establish that intimate relationship, you earn the right to ask personal questions and make observations according to the facial expressions and words not said by your mentee. Victoria gives a very visceral description of what it's like to be mentored by the "village":

When I was experiencing one of the darkest days in my family life, and my marriage was disintegrating before my very eyes, I grew weak and went through a serious time of depression. God brought my old and new spiritual moms and sisters together to help me stand. I felt like I was locked inside a fortress lined with velvet. They were firm, yet gentle and empathetic. I remember one of them suggesting that I go on medication. Another one said when I asked her about this, you can go on medication, there is nothing wrong with that, or we can pray you through. I

opted for the prayer. I'm standing today because of their admonishments and prayers.

This village "fussed over" Victoria, providing an environment where she could be alternatively challenged and comforted as she went through one of the most difficult times a woman can experience.

And so what have we seen? That discipleship can be formal or informal, but that the informal process is a great way to prepare for the more formal relationship. We've learned that discipleship is most effective when a number of women take on various discipleship roles in a woman's life. It can be at the same time or it can be more progressive, with a woman for the different phases of her life. And we've learned, through the testimonies given, that the Word of God is the only legitimate basis for providing true discipleship.

6

On Location

⁓❦◯

*D*iscipleship can take place in a variety of places. Church is one such place. But in reality, most of the discipleship process happens outside the four walls of churches. It takes place in coffee shops, malls, cars, school halls. And of course, it takes place in homes.

IN THE HOME

When we think of discipleship in the home, we can include the ways in which discipleship takes place within families. Mama Lucy is the earliest example of an African American female mentor in this book; she was born more than a hundred years ago. I wish we had more examples from years gone by, but Mama Lucy represents millions of women who have had a positive impact on the life of another woman. In this account, her impact also happens to be on a family member, her granddaughter. Here are some words of Mama Lucy, as told to that granddaughter, Rosie Lee Perkins.

The Lord is my shepherd, I shall not want (Psalm 23). That is the Scripture that gave me joy when I was in sorrow. It gave me hope when I was ready to give up. Those are the words that allowed me to know that my life was going to be all right as long as I let the Lord lead me.

You see, I was born in 1893. Back then, we had to work in the cotton fields to make a living. I can remember singing those old Dr. Wyatt's hymns as we labored in the sunshine. That was the time that we could reflect back and talk about how good God is to us. Despite the hard labor, the Lord had never failed.

Mama Lucy reflected on her earliest days, her family and her church:

I was taught to cook when I was eight years old by my grandmother. I used to accompany my aunt in cooking for a Caucasian family nearby. One day, my aunt got sick and could not finish preparing the meal. At eight years old, I charmed the family when I boldly exclaimed, "I can cook." Needless to say, I got the job. Ever since then I have been in the kitchen, cooking up hot meals for my family, friends and strangers too if they were hungry.

I attended the Emery Church in Murfreesboro, Tennessee, which was established by my family, the Crawfords. This one-room church also served as our schoolhouse. I was not as fortunate as young people in your day. I only received a fifth-grade education because we had to work in the fields from August to October.

Now Mama Lucy's granddaughter speaks. We get an idea here of the impact that this nineteenth-century grandmother had on her twenty-first-century granddaughter:

This is part of the life that gave me such inspiration. I am the granddaughter of Lucy Crawford Ross. She taught me how to work and to be independent. Mama Lucy, as we affectionately called her, always told me to trust in the Lord and not man. She also told me if ever someone comes knocking at your door hungry, give them something to eat.

My grandmother lived to be 103 years old. After she crossed over, I told my family that we needed to get together more often. There are so many families that lose contact with each other and just go their separate ways. They don't see each other until there is a funeral. I did not want my family to be that way. So we started having Bible study, which later evolved into a group of family and friends who are now known as The Working Disciples for the Lord. We get together twice a month to study the Bible and fellowship. We also visit the nursing home twice a month.

Clearly, Mama Lucy's granddaughter had a relationship with her grandmother, who had a relationship with the Lord that she lovingly passed on:

My grandmother was a God-fearing woman who instilled the love of God in me. Mama Lucy always told me to treat others as I would want to be treated. I am so glad that I had such a wonderful woman in my life to teach me and love me. It is because of Mama Lucy and others that I am the God-fearing woman that I am.

Here we see one of the many ways that discipleship can impact a young person's practical life, as when Mama Lucy talks about learning how to cook. Mama Lucy is credited with the continuation of family gathering and closeness, as well as

Bible study and outreach. Mentoring others can be intentional, or it can be a byproduct of a life lived in front of others in your home.

IN EDUCATION AND WORK

DeAnna DeForest is a young woman who caught the vision of discipling others while at college. In her senior year in college, she felt a strong desire to minister to sorority women, who were often stereotyped as promiscuous alcoholics. She started with a small group from one sorority, which grew to include women from all three sororities on campus. Toward the end of the semester, this single group grew from sorority women to African American fraternity men to individuals who were not in a Greek organization at all.

DeAnna described one woman in particular who had a desire to serve the Lord but never felt that she could as a college student:

> She knew that she had a personal relationship with the Lord when she was at home, but when she was at school she felt like she wore too many different hats to have time for the Lord. She began to learn by attending Bible study that God does not leave us, although we put Him aside. While we were ministering from the book of James, she learned that slipping up in our daily walk does not mean that we must continue in our sinful nature, but that we may make a mistake but we are to continue to strive toward the kingdom of God.

When DeAnna graduated, this young woman decided to continue on with the small group as a leader and began being diligent about the Word of God and studying on her own.

Mentoring can happen in the professional and business

worlds as well. Princess-O'dilia was a businesswoman mentoring a young woman from a professional perspective, coaching her through how to change her business strategy as the market shifted. They eventually began to think of their relationship as mentor and mentee.

Sometimes, your mentee exceeds your expectations. She may even exceed *you*. That had to be okay with Princess if she was to continue as an effective and godly mentor. Instead of hiding her struggles from her mentee, Princess shared them openly as she shared valuable life lessons.

> This young lady began to soar to the top despite the poor economy, and I who had initially done *very* well was beginning to have some turmoil in my business. Tables had turned, but as I watched her excel, I was glad to see that she was doing so well: on the Web, hosting huge national events and seminars, making money with the strategies that we talked about, etc. It was *awesome!*
>
> I shared my pitfalls and my error, and let her know that my setbacks would be the source of my growth as I learned the lessons. I would encourage my mentee not to make the same mistakes that I did. Sometimes this part of keeping it real really hurt and was embarrassing.

As we grow in faith, we will make mistakes. It took me a while to understand that when things don't go right, I need to first be sure that the object of my faith is God and not any human begin or thing (tough lesson). When someone is looking up to you as a mentor in your profession, it can be challenging to mentor her and to face personal disappointment and faith challenges at the same time.

It is great for women to impact the lives of others in our churches, our homes and our places of work just by being good

Christians. Just think of the power and positive reverberations of hundreds or even thousands of women who decide to take the command given by the apostle Paul in Titus and do it deliberately. I call that intentional discipleship.

IN MINISTRY

Now we come to one more natural place for discipleship to take place—in formal ministry. The passage we have used from Titus is a clear example. Titus was a disciple of Paul. Paul wrote instructions to him found in the book of Titus, from which we find our guiding Scripture. Timothy also was a disciple of Paul, as were probably many others. Paul taught these young men in the process of ministry. He wrote them letters, but he also took them with him on some of his mission trips (see Acts 18:1-20).

As I am writing this section, I am at my daughter's house. She is in South Africa with her pastor on a missions trip. I'm sure she will learn things from her pastor and the assistant pastor that she might not have had an opportunity to learn in another setting. This is an example of training the younger. When we do ministry together, we have a chance to impart into the life of another.

Truly, discipleship is one of the better ways of training women in the home, at school, on the job and while doing ministry. Let's put our hands to the plough. We could be on the edge of a reformation.

7

Tips for Getting Started

—❦〇

*A*re you convinced that spiritual mentoring is for you? Do you feel now that you have a handle on what is involved and how to get started?

Let's say you have made the decision that you would like to be obedient to the Word of God and disciple a younger lady. You have also decided whether you will work with a group or with one or more individuals one-on-one. You have also determined that you will either work alone or with another Christian sister. After coming to a conclusion on all of the above, the next question is, what do you do next?

EXAMINE YOURSELF

One of the first things we need to do prior to getting started is to examine our own relationship with God and, if need be, fix or pay attention to anything that is amiss. I am not saying that you have to be perfect, but it is good to be aware of things that need attention. Believe me, a mentoring relationship will ex-

pose your weaknesses. We all have them, so don't worry. Those
are the places where God's strength comes in abundance.

There could be any number of things going on with our rela-
tionship with God. Many times, we may not even be aware of
them. So before we get started, this is a good time to do an as-
sessment. To find out if we have anything that needs to be
worked on, we need to ask God. He knows our hearts better
than we do. Psalm 139:23-24 is a prayer in which the writer
asked God to search his heart. We can do that as well.

Search me, O God, and know my heart;
Try me, and know my anxieties;
And see if there is any wicked way in me,
And lead me in the way everlasting.

If anyone knows us, God knows us. God knows the hidden
things of our hearts. "Would not God search this out? For He
knows the secrets of the heart" (Psalm 44:21).

If after asking God to search our heart, we find that there is
someone we need to forgive or we find that there is a rift with
God, we have an obligation to deal with it. Get out of the rut
with God. Get out of the rut with others. Forgive someone. It's
God's work, and it isn't about you. God will search our hearts
and bring the answer according to his perfect will. It is impor-
tant in anything we ask, to ask according to God's will. Let go
of a self-centered, it's-all-about-me perspective and know that
it's not about you, it's all about him and his purposes. Live your
life for eternity, not for what's down here.

DO NOT BE EASILY OFFENDED

It's a fact: hurting women hurt others. If you are going to min-
ister to women, put on some thick skin. It's part of the price for
ministry. Prepare to be hurt in the process, and then it won't

surprise you when it happens. And it is going to happen; it's par for the course. But the price is worth the prize. So learn to get over it.

Also prepare yourself for rejection, which is part of the cost of spiritual mothering. After all, Jesus sought his Father's approval because he was about his Father's business. He really was not concerned with man's approval.

One lady I know desired to be mentored by someone who worked in the field where she felt the Lord was leading her. She volunteered to work for this person with the understanding that the woman would be her mentor, especially in the area that she felt the Lord leading her into. She volunteered for a whole year, but came away terribly disappointed in the mentoring experience. And as I've already mentioned, when I was a budding writer, I went to a conference and asked the conference's noted author-speaker to mentor me. The woman's response was, "Read my books." At the time, it appeared to me that this woman simply used my appeal as an opportunity to sell more books.

> The cross is not something heavy to bear with our heads down and a heavy heart. The cross is a place to put our *stuff* so we can run this Christian race with endurance and *joy!*
>
> Victoria Johnson

These things will happen. Mentors and potential mentors will disappoint us. At the same time, we are sometimes disappointed by those we mentor. When this happens, don't shut your mentee out of your life. It's important to continue to pray for her. We have spoken of the many people whose lives were impacted because someone took the time to pour into their life. However, people still make their own choices, no matter what they might have been taught. Just as our children disappoint

us, we can be terribly disappointed by some of the decisions our mentees make. It can be devastating—very painful. Your mentee may choose to live with her boyfriend instead of getting married, even after you showed her from the Scriptures what God designed. (I must add that you do need to show her from Scriptures; otherwise she may think you just made it up.)

ACT IN AGE-APPROPRIATE WAYS

One mistake that some people who are of my generation make is trying to be too hip. They try to talk, walk, dress and act like twenty-somethings. Don't do that. Be yourself. Young ladies need a mother figure, not a homegirl. Now, that does not mean you won't forge genuine friendships. To have these kinds of friendships, though, we need to be authentic, not fake.

LET LIFE STAGES DICTATE
YOUR ACTIVITY LEVEL

I can't say that I have been a flawless keeper of my home one hundred percent of the time, but I think, on the average, I've done an okay job. I also think I have experienced what most mothers go through at one time or another: I have been a stay-at-home mom. I've been a full-time working mom and wife. I've experienced being a "single" mom. (My husband was in Nigeria for some time while I was in Chicago; part of the time the children were with me, part of it they were with him.) I have been a homeschool mom. I have been a working mom who has also been in ministry. I have worked full time outside the home, and I've worked part time outside the home. I have been a volunteer. I know the struggle of trying to find enough time in a day to get it all done. At various times in my life, my plate has been more than full.

In spite of all we do (though I'm not really sure we should be

doing all we are doing), we cannot ignore our responsibility to other Christian women. I did not say we all have to have a Bible study in our home as Sister Julia Meadows and I had. The fact of the matter is, I don't have one in my home at this time, but I still have to be about my Father's business.

We go through different stages in our lives. In the early stages, it may be more important to get spiritual mentoring. In another stage, we may feel more impressed to give back in a formal way. In another period, we may do more informal discipleship. A lot depends on what else is going on. I was not working outside my home when I made an attempt to disciple twelve women. The times I worked full time and did ministry, discipling others was more on the back burner. I did it, but certainly more informally and more impromptu—a lot less intentional.

> Mothers need to instill values and God-fearfulness in children. It's the hands of moms that shape the senators and leaders of our country. The relationship with our Creator and with each other is influenced a lot by mothers.
>
> *Denise Lacey*

TELL YOUR STORY

Allow me to offer a suggestion: if you're a mentor, get help from your mentee to write your life story or your testimony, including how you met God, how he drew you close to himself and how he met your needs. I think many older women could benefit from allowing a younger woman to help them write their story.

However, although every older woman should consider writing her story, not all stories become a book. Very few women's stories will qualify as national bestsellers. But everyone de-

serves for her story to be told in some form. It may be handwritten in a lined notebook. It may be typewritten or in a computer-generated form. It may be taken to the local copy shop to be printed and bound.

"Who'd want to read my story?" you might ask. You'd be surprised how many people might benefit from your story. It might be your natural daughters, your spiritual daughters or members of your church.

We must tell our stories, even if it's just telling them orally. We can tell them as many women do, by giving a testimony in church, but, if at all possible, they should be recorded so they can live on for posterity. Keep in mind, too, that our stories don't have to be told all at once; they can be told in installments. We tell them to help others avoid the mistakes we made. We tell them to encourage others. We tell them so that others know it does not take a perfect person to qualify for God's use. We must tell our stories to help others. That's part of the discipleship process. We can't just teach the Word in a vacuum. We have to share the Word of God in the context of our lives and how we have interacted with God. Everyone has a story, and everyone's story needs to be shared with someone.

ADMIT WHEN YOU ARE WRONG

One of the essentials of discipleship is humility. The important thing to do when you make a mistake is to admit it, learn from it and move on. A mentor cannot afford to be dishonest because of pride. A young lady told me how her mentor had lied about a situation. Not only did she lie, but she did in a way that put the mentee in a bad light. How tragic. This brought hurt to the mentee. Dishonesty is just not right for any reason.

We can't let pride keep us from admitting when we're in the wrong. In fact, we may need to check with those we mentor on

a regular basis to find out if we've done things to hurt her or if we've made some mistakes. Most people are very forgiving. Making mistakes is part of being human. We learn from our mistakes. We grow. It's all good.

CALL YOUR SISTER

Another thing to remember: don't expect the person you're mentoring to be the one who calls you all the time. Once a mentoring relationship is established, pick up the phone every now and then, and call your mentee to find out what's going on.

> Don't be afraid to show your hurts, your anxiousness or anxieties. He will never leave you. Don't be afraid to cry. He bottles your tears as he showers you with his unconditional love.
>
> *Thelma Mason*

You are the one responsible for teaching the younger woman, so the onus is on you to take the initiative to reach out and to do what we've all been called to do.

DON'T EXPLOIT THE RELATIONSHIP

Don't expect the person you're mentoring to serve you. Sometimes a woman serving a public speaker is called an "armor bearer." I've seen armor bearers carry their mentor's bags, Bible and other belongings. It's almost as if the mentor can't do anything for herself. Now, I know many people love to serve. It's their gift. They offer to carry the bag. They want to. I've had people insist on doing things for me when I've spoken at places—things I really could do for myself. Sometimes, in order not to make a big scene and if they continue to insist after I indicate it isn't necessary, I let them do it. It's not that big a deal. But a minister of the gospel is supposed to have a servant attitude, not a Queen Victoria attitude where everybody must wait on her hand and foot.

If you need people to help you with cooking or housework or running errands, find someone you can employ to do those things. Or you may be able to find an agency that will send volunteers over to help you. Just be careful that you don't make it a requirement for your mentoring. If a mentee offers, that's okay. Let the teaching be the major emphasis of the relationship.

In all my mentoring relationships, I have not expected the mentee to give to me. God has always had me emphasize what I can give to her. That's why when someone wanted to give to me, I was honored, surprised and thrilled. I didn't refuse it. I believe God was behind it. But that cannot be an expectation of a mentoring relationship. Those I've discipled have gone on trips with me, helping me with the driving and logistics. They have helped with projects, like putting booklets together. They have edited materials. They have done bookkeeping. They have even helped with housework. One group desperately tried to get my papers in order and get me organized, but it just didn't work. Maybe I'm beyond hope where those things are concerned.

Jesus did allow people to serve him. A good example was the woman who washed his feet and dried them with her hair (see Luke 7:36-48). Jesus let her do it; he was able to receive service. But I don't see Jesus telling John to bring him some water. Nor do we hear him telling Thomas to wash his feet or carry his things for him. Granted we don't know exactly how it went, but I'm just saying, we don't see that picture anywhere in the Gospels. On the contrary, we see Jesus going to the well to get water. We even see him going out of his way to demonstrate service by washing his disciples' feet.

> Jesus, knowing that the Father had given all things into His hands, and that He had come from God and was going to God, rose from supper and laid aside His garments,

took a towel and girded Himself. After that, He poured water into a basin and began to wash the disciples' feet, and to wipe them with the towel with which He was girded. Then He came to Simon Peter. And Peter said to Him, "Lord, are You washing my feet?" . . .

So when He had washed their feet, taken His garments, and sat down again, He said to them, "Do you know what I have done to you? You call Me Teacher and Lord, and you say well, for so I am. If I then, your Lord and Teacher, have washed your feet, you also ought to wash one another's feet. For I have given you an example, that you should do as I have done to you. Most assuredly, I say to you, a servant is not greater than his master; nor is he who is sent greater than he who sent him. If you know these things, blessed are you if you do them. (John 13:3-6, 12-17)

We need to have an attitude like Jesus'. He was the Son of God; he is called the King. Yet he served. As older women who mentor younger women, let us never give the impression that we are better than the younger women. The younger may not have equal experiences, but they certainly have equal worth. We should never make those we mentor feel inferior. It is very possible that they may outshine us in ministry if indeed they have a ministry call. That's a good thing, one we should encourage.

HOLD TO THE STANDARD

When I was young, moral standards were pretty well known by most people. Not that everyone followed what was considered moral, but at least everyone knew what was considered right and wrong. Unfortunately, these days, things that used to be considered immoral are now commonplace. Some people do not realize that living together before marriage is considered

against God's design. So be sure not to neglect teaching God's standards. If your mentee chooses to go against it, it's on her, not you. You've done your part (see Ezekiel 33:8).

The following is from a friend who invested a lot of time and energy into a young woman, only to see the young woman defy the things she had tried to teach her.

As a woman in my thirties, I longed to get it right. Of course, I didn't always, but I constantly tried. I experienced quite a bit of pain getting to the place where I am and had a desire to help other young women navigate around as much pain as possible. That leads me to my story and what I learned about mentoring.

Sunday worship on a warm summer morning with family and friends—that's where I met this young woman. "Am I saved?" That was what she wanted to know. She really wasn't sure and didn't know how to find out. Prayer was the link that bound us together. Ours was something of a mother-daughter relationship, and that was a misstep on my part. We really should have been sisters.

Our relationship formed quickly, and we became close. In what seemed like only a few weeks, I received a call from her, and she asked me to sit down. I did, and she very sorrowfully told me she was expecting a baby. She was educated and financially caring for herself but really alone. She was not just alone physically, but emotionally and in some ways socially, with almost no friends.

My friend advised her according to God's standards.

We shared a lot, and I encouraged her to have the baby and not to abort, but instead trust that the Father would honor her desire to do what's right over what's easy. She

was so fragile that an abortion would likely damage her spiritually, emotionally and possibly even mentally. Without hesitation she made her decision.

During the pregnancy she experienced some normal stress and some abnormal stress. She was being laid off from her job and needed to find a new job. We both knew that, being very pregnant, that wouldn't be easy. So she stayed until they laid her off; she had the baby and then moved in and became part of our family.

This was a noble act on my friend's part, but when you bring someone into your home, you have to be very careful to set the right expectations.

We prayed a lot over the phone and even at her place or my place before she moved in. Once she moved in, she became part of the family and we kept our normal schedule—all to her surprise. We didn't pray together every day—I have a husband and three children along with a full-time job, and I was in school full time. I didn't have time to baby her every day. Besides, she had a baby to baby!

When it came to family, she was the best. She took care of the baby and prepared dinner for us regularly. She even wanted to assist in doing laundry. She was great with my kids, helping with homework and playing the big sister in a great way.

But there was trouble in paradise. And it all had to do with standards, structure and expectations.

We struggled when it came to men in her life. She needed to be wanted and wanted to be needed. The baby's father was still in her life, or rather in and out of their lives, and that made for a very difficult transition from single woman

to single mom instead of "family of three." During this time, my focus should have been structured. Although I loved giving to women in need, I didn't realize what I should have been doing. Instead of structuring important things like prayer and times of counsel, we opened our home and continued life as usual.

In hindsight, perhaps we could have had a Bible study or regular times of sharing about living the Christian life. I thought that because she was there with us she'd see "real" life for a family of believers and that alone would make a big difference. *Wrong!* This lack of structure and me not making time to teach the Scriptures proved to be a challenge for her because she didn't know how to connect to our Father.

What do you do when your mentee is deliberately disobeying God's instructions conveyed in his Word? Well, we have to refer to the Word for the answer.

Moreover if your brother sins against you, go and tell him his fault between you and him alone. If he hears you, you have gained your brother. But if he will not hear, take with you one or two more, that 'by the mouth of two or three witnesses every word may be established.' And if he refuses to hear them, tell it to the church. But if he refuses even to hear the church, let him be to you like a heathen and a tax collector. (Matthew 18:15-17)

I wrote to you in my epistle not to keep company with sexually immoral people. Yet I certainly did not mean with the sexually immoral people of this world, or with the covetous, or extortioners, or idolaters, since then you would need to go out of the world. But now I have written to you not to keep company with anyone named a brother,

who is sexually immoral, or covetous, or an idolater, or a reviler, or a drunkard, or an extortioner—not even to eat with such a person. (1 Corinthians 5:9-11)

Though the first passage refers to someone who sins against you, I believe it is relevant for those whom you observe in sin. The sin is not limited to sexual immorality; it could be other blatant sins as well, such as drug or alcohol addiction. When someone habitually sins, has been counseled, confronted, and shown what God says, and she continues in sin with no repentance and no attempt to get free, the only choice we have is to discontinue the relationship.

It is important to have a conversation with her concerning why you are choosing this action. You should not cut someone off without explanation and without giving her an opportunity to make changes. Make those expectations and the consequences crystal clear to your mentee.

BE REAL

Thelma Mason is a people person. She has worked in various industries, including full time for United Conference for Women in numerous capacities since 1987. She was an old friend of my folks who encouraged my mother to talk about her ALS diagnosis when my mom was preparing to speak in Atlanta.

The youngest of eight, Thelma was born and raised in Detroit. She had numerous health issues as a young lady, including tumors on her lungs, tuberculosis and other issues. She spent more than a year in the hospital and was incapacitated for almost two years. Now in her early seventies, Thelma and her husband, Herbert, have one grown daughter

> Be real. Strive to become a Proverbs 31 woman.
>
> *Thelma Mason*

and two grandchildren. Thelma gives very good advice that you
can share:

> Study God's Word daily, meditate on it, pray always, don't
> fret. Trust His word, stand on His promises, rest and wait.
> . . . Don't move . . . be completely still . . . inward and out-
> ward . . . wait. He will give the desires of your heart that
> . . . He wants for you . . . as He melts you . . . molds you . . .
> and fills you with His Spirit . . . and you become His like-
> ness. Lean not to your own understanding. . . . He will direct
> your path. Philippians 4:4-9: Don't worry. He gives peace
> that passeth all understanding. He gives perfect peace. He
> will keep your heart and mind in Him. . . . Think on the
> good things. Don't try to hurry Him. His ways are not our
> ways . . . don't jump ahead of Him. Be real . . . let others
> know the real you . . . be yourself . . . don't wear a mask . . .
> don't put up a front. As you show love, you will learn to love
> yourself more. Don't be afraid to show your hurts, your anx-
> iousness or anxieties. He will never leave you. Don't be afraid
> to cry. He bottles your tears as He showers you with His
> unconditional love. Become an encourager, a giver, a good
> listener, a true friend. When a friend shares with you, . . .
> you become their prayer warrior. . . . You share that with no
> one else but God. Become a willing vessel for His use.

> Strive to become a Proverbs 31 woman. Be a good ex-
> ample to other women . . . "being confident of this very
> thing, that He who has begun a good work in you will com-
> plete it until the day of Jesus Christ" (Philippians 1:6).

BE PROACTIVE

It's not all up to the older women. This book would not be com-
plete if it did not give younger women ways of helping make the

process possible and workable. You have some things to do as well if discipleship is to become what it needs to be among African American females.

As a younger woman, you need to be proactive in finding and helping women disciple you. Sometimes mature women need help. We can sometimes be intimidated by the energy, smarts, youth and technological know-how of your generation. Sometimes we project our own fears and reluctance onto the young people we would like to mentor. Be cognizant of these things and help us out. Be persistent. Be patient. Don't give up on us. Ask us to mentor you if we don't ask you.

I have probably let some young people down who wanted to be discipled by me. I may have missed the clues and cues. I may have felt I was too busy. And I can think of several cases when I did drop the ball. I know I have messed it up. I'm sure people have been disappointed in me for a variety of reasons. I know I have not been as diligent as I should have been in reaching out and maintaining relationships. Since I have missed it with young women, I would guess that many of us have missed it.

So, young women, don't let us off the hook. Don't give up on us. Be bold. Be clear. Be specific in asking us. Yes, you'll risk rejection. Believe me, there have been times I was not in the condition to pick up on blatant cues from someone who might have wanted me to mentor her.

If your mentor of choice is not in a good season to be mentoring—she is raising young children, homeschooling, working, keeping her home—just know that she's receiving the life experience to mentor someone at another point. It may not be you, but hopefully when the time comes, she'll pass it forward. The other possibility is to offer your mentor of choice help in the things she needs to free up her time. Why not take her children out for pizza, giving a frazzled mom a needed break. If you

did that several times out of love, she may find a way to make time for you in her busy schedule.

Work with us. But if one woman can't work with you, keep looking to find someone who will.

BE "FIT"

Rhonda Smith has been discipling teenagers and young women for nearly ten years via Sunday school classes, monthly meetings and phone calls, and prayer partnerships. As an experienced mentee and mentor, she is well qualified to provide this wise counsel about the most important qualities that mentors and mentees must have:

> One of the main things I have learned from discipling women is that there must remain a level of FITness on the part of the disciple and the discipler. FIT is the acronym used in the discipleship ministry at Evangel Ministries in Detroit, and it stands for faithful, interested and teachable for the disciple, and for the discipler a solid faith foundation, integrity and training.

Rhonda shares with us that there must be a hunger on the part of the mentee to learn and a willingness on the part of the mentor to teach. Otherwise, the relationship is like a bad marriage. So each woman needs to keep these tips in mind before she enters and while she is in a discipleship relationship:

- Be prayerful.
- Remember your place. *Disciple* means learner and, therefore, the discipler is the teacher. These roles may overlap at times, but each has its primacy. The disciple should be humble and willing to learn; and the discipler must not lord her authority over the mentor. She should remember that she is there to

teach her mentee, not force her to do anything. Let Titus 2:3-5 be your guide.

- Understand the role of spiritual authority (*Spiritual Authority* by Watchman Nee is excellent on this).

- Know when it's time to end the relationship (that is, when the disciple no longer respects the discipler's judgment or when the discipler no longer gives biblical direction).*

*This biblical leadership process is used with permission from Phillip Carr, ©2009.

8

A Model for Structured Mentoring

*I*n the discipleship process, from the mentor's point of view, there are just a few basic steps:

- Identify the mentee.
- Pray.
- Establish a relationship.
- Set goals together.
- Commence the discipleship process.
- Achieve closure.

IDENTIFY THE MENTEE

Open your eyes to find someone to mentor. Ask God who it is in your life that he desires you to impact. She could be a co-worker, a neighbor or a fellow church member. She could be someone you just met or someone you've known for a long time. Many times, she is right there in front of us—if we just open

our eyes wide enough to see her. It could be your own daughter, daughter-in-law, niece or neighbor.

In her book *Papa Was a Rolling Stone*, Robin Wright King writes about having an absent father. She connects with other women who have had similar experiences, and much of her connection is done via a website. While using the Internet as your sole discipleship method may not be valid—discipleship should be up close and personal—it can be a great avenue for finding a potential mentee. Connecting with someone on Facebook, for example, could possibly lead to a mentoring relationship. The Internet can also be useful in some aspects of the discipleship process. I have answered many questions of disciplers and disciples alike via the Internet. One former mentee I'd had trouble locating recently found me through Facebook. When you include this newest Internet development—social networking—you can see how technology has changed so many things. Only time will tell where the trend might lead in using technology in discipleship.

You might also consider starting a Bible study and asking younger women if they want to join. To find young women for a discipleship group, Gina and I did a seminar on women-to-women ministry. My son has a ministry to young people, so I had him send out the information to females on his email list because we were looking for young women. At the seminar, we announced that we wanted to start a discipleship group and asked if anyone was interested. We began with those who responded.

PRAY

Before you approach your identified mentee, do this one thing: pray, pray, pray! Prayer can clarify if this person is the one or not. Jesus spent a whole night in prayer before he chose his disciples:

Now it came to pass in those days that He went out to the mountain to pray, and continued all night in prayer to God. And when it was day, He called His disciples to Himself; and from them He chose twelve whom He also named apostles: Simon, whom He also named Peter, and Andrew his brother; James and John; Philip and Bartholomew; Matthew and Thomas; James the son of Alphaeus, and Simon called the Zealot; Judas the son of James, and Judas Iscariot who also became a traitor. (Luke 6:12-16)

Prayer can prepare the heart of the person you want to approach before you approach her. Prayer can tear down resistance that might be present. Prayer can soften her heart toward you. Prayer can even make her aware of a need to have a mentor. When you pray, ask God to open a door, that you might be able to connect with her.

I'm reminded of the prayer Paul asked to be prayed for himself: that a door would be open for him to preach the gospel. In the same way, we ask for an open door to have an impact in the life of a younger woman: "[Pray] also for us, that God would open to us a door for the word, to speak the mystery of Christ, for which I am also in chains" (Colossians 4:3).

Prayer will also prepare your heart toward the person and the process. You can pray that the Word of God would have free course in your life so that you can be effective as an older woman in the life of a younger woman: "Pray for us, that the word of the Lord may run swiftly and be glorified, just as it is with you" (2 Thessalonians 3:1).

ESTABLISH A RELATIONSHIP

Once you've prayed and received clearance from God, begin to reach out to the mentee you have identified. We don't always know

to whom we need to reach out, but since God wants us to do this, I'm sure he'll answer our prayer of who we need to disciple. If people seem to hang around us, want to get together with us or ask us for our input in their lives, this is the answer to our prayers.

I believe in moving until I hear a clear stop, rather than waiting around, not doing anything, trying to see if something is God. God cannot steer a parked car, so start moving. As you're moving, be open to God steering you in another direction if need be. It really is okay if you miss it on who you should disciple. At least you made a move. You have given God a chance to give directions.

It's great when we feel drawn to someone and feel led to take her under our wings. But that is not always how it happens. If a young woman asks you to disciple her, that's a strong indication that this may be a person for you to disciple. I was talking about this book to someone recently, and she mentioned that her stepdaughter had asked her if she would help her study the Bible. Her prayer was answered before she even prayed. However, it is not always that cut-and-dried. You still have to seek clarity on God's will.

Sharon Guy from Memphis had someone ask to be mentored, and here's what happened:

> Masterlife [a published resource of materials to be used in the discipleship process, which is available from B&H Publishing] started when my daughter-in-law, Tiera, came

Over the years, we have seen an increase in our divorce rate, the number of unwed mothers, child neglect and abuse. I believe in part that this is the results of young women trying to navigate marital relationships and motherhood without mentors.

Adelle Dickinson

to me and told me that she was tired of her life and needed a change. That very evening, she accepted Jesus Christ as her Lord and Savior. She was immediately hungry for the Word on a daily basis; she would beg me to do Bible study with her and my niece, Angel. After she was so persistent in asking, I decided to do the *Experiencing God* study by Henry Blackaby and Claude King with the two of them.

Somehow the word got out about the Bible study, and I ended up with over twenty women in my home every Sunday afternoon. I was caring for my ninety-two-year-old uncle at the time, and it was rare for me to attend church on Sunday for fellowship, but God allowed me to have fellowship in my home with these ladies from many denominations—Baptist, Southern Baptist, Missionary Baptist, Catholic, Seventh-Day Adventist, nondenominational, Church of God in Christ, and even Buddhist backgrounds. But when we got together in my den, we all began to allow the Holy Spirit to teach us.

This is a perfect example of what I'll call "spiritual snowballing." When you start walking in God's way, doing what he says, following the process, he opens the door for you to have a real impact.

After the death of my uncle, I began to teach Masterlife at my church. My pastor, Robert West of One Faith Fellowship, gave me permission to teach Masterlife at church on Sunday mornings as well as Wednesday nights. I also had classes going on at my job . . . on my lunch breaks, and some of my coworkers would come to my house two hours before the start of their tour to study Masterlife. After the word got out how people were seeing change in their family and friends, several women and men would come from other

churches on Wednesday evenings and Sunday mornings to study Masterlife to take back to their own churches.

Let me get back to the practical ways to find someone to disciple. Once again, look at members of your own family. My daughter-in-law, Shereena, attributes her mom with teaching her a critical area of Christian living.

The most memorable experience I have had with female discipleship has been with my mother. My mother got saved when I was about five or six years old, and I was saved when I was seven years old. Growing up, I watched my mother live a holy life before the Lord. She was not a perfect woman, but I watched her strive for perfection in Christ. One of the greatest things she taught me was that I was a valuable person and that I was worth too much to give my body away to men who did not deserve it. She taught me that the only man that was worthy enough to have me was a man who was willing to make a commitment to me before God and take me in marriage. My mother was very open about sex with me, sharing with me bad experiences she had and mistakes she made. She made it clear that she intentionally shared those things with me so that I could have the wisdom not to make the same mistakes.

Shereena's mother was open about the mistakes she had made, and her daughter received the benefit.

When I was in the seventh grade, I got down on my knees and prayed, telling God that I wanted to be a virgin when I got married and asking Him to keep me pure sexually, even when I did not want to be kept pure (unto Him that is able, Jude 1:24-25). God honored my prayer. Through the temptation I faced, the Lord kept me and lifted me even in

times of weakness, always making a way for my escape. And on June 29, 2008, I was presented to my husband a virgin, kept by God, guided by my mother's wisdom.

SET GOALS TOGETHER

It is important to have a goal of what you want to accomplish. Do some preliminary thinking on tools you will use. Start by looking at who you are—your talents, gifts, purpose and training. For instance, if you are a gifted teacher, you would probably do well with research, word studies, maybe even topical studies. One of the purposes in my life is to help people mature, so I tend to select those things that will facilitate that process, whether it is a book or a book in the Bible.

Another matter in which you need to set a goal is the length of time you will be in an official discipleship relationship with the group or individual. In some respects, once a disciple, always a disciple, but there is an intensive period that does not last forever. For Jesus and his disciples, it lasted three and a half years. I would suggest one to three and a half years as a reasonable range for the intensive process. You will have to determine whether you can make such a commitment. Can you meet weekly, biweekly, monthly or according to some other time frame?

In the book *Woman to Woman: Preparing Yourself to Mentor,* Edna Ellison says that a written contract or agreement is very helpful. I have never used one; you will have to make that decision based on you and your mentee's styles. The important thing to remember is that you and your mentee are in this together. You'll set goals together, as well as meeting times and frequency. Obviously, there will be give and take. Then whatever comes out of that discussion will be things you both can buy into.

COMMENCE THE DISCIPLESHIP PROCESS

Of course, the next step is just to get started. And what better way to start than with God's Book?

Bible study. There are several reasons for doing Bible study together:

- It's the unadulterated Word of God, according to 2 Timothy 3:16-17: "All Scripture is given by inspiration of God, and is profitable for doctrine, for reproof, for correction, for instruction in righteousness, that the man of God may be complete, thoroughly equipped for every good work."

- The Bible is the one book we have been instructed to study: "Be diligent to present yourself approved to God, a worker who does not need to be ashamed, rightly dividing the word of truth" (2:15).

- The Bible prepares us for God's work: "All Scripture is given by inspiration of God, and is profitable for doctrine, for reproof, for correction, for instruction in righteousness, that the man of God may be complete, thoroughly equipped for every good work" (3:16-17).

Obviously, I don't think it is wrong to study Christian books, but if you want to get the most bang for your buck, studying a book in the Bible is better.

Book studies. Studying a Christian book rather than studying a book in the Bible may be advantageous in a few different scenarios. A very new believer might get more out of a book that is geared toward leading her to the Word of God or helping her get around in the Word of God. A group of seasoned believers who have spent years studying the Word of God can benefit greatly from the study of other books. And a good book study that frequently uses Scripture may help believers who have been in the church world a long time get into the Word more. It

might even make them excited about studying the Scriptures.

My friend Gina Watson and I once discipled our own group of young women. We all met every other week, studying my book *Chosen Vessels: Women of Color, Keys to Change.* In fact, discipleship is how Gina and I became friends. She was discipling a group of women in her home, and I was discipling a group of women in mine. I heard about what she was doing and wanted to meet her, so I came to her home during one of her meeting times. She later told me she thought I was coming to steal some of her mentees, and we had a good laugh. That was the furthest thing from my mind. We eventually decided to pool our groups and study together.

When using a book as a group study, you must do a little more work as the mentor. Most books do not have questions at the end of each chapter, so you may want to restrict yourself to those that do. If a book you'd like to use doesn't have discussion questions, you or someone else could develop some.

Notice that I said "you or someone else." You could get someone in the group to do it, or you could find someone outside the group, such as a seminary student, a Sunday school teacher or someone who likes doing such things. Give the person sufficient guidelines, such as asking for questions that provoke deep thought, questions that make for lively discussions or questions that add fun and humor.

In one series I did with a group of women, I used a book, but I also developed Bible studies to go along with the chapters. Sometimes these are already developed for you by the book publisher. This was the case in a study I did with a group of ladies: *Setting the Captive Free* by Beth Moore, which was designed to be either an individual or a group study. It has homework assignment, Scripture readings and discussion questions. For a mentor, this kind of study is a no-brainer. Some ready-made curricula

like this includes video presentations of the author teaching on the subject. The package allows you to focus on the delivery of the material, because the major work has been done.

A final note about books: as much as I may trust my own writing, let's face it—I cannot claim that every word, every sentence, every concept is written under the inspiration of the Holy Spirit. It's the same with any author. You have to eat the meat and spit out the bones. Just make sure you find books that don't require you to do that on every page, which could get tiring, or confusing for less mature believers.

Topical study. A topical study using a variety of materials can work for a group or one-on-one. This approach takes much more time and effort to pull off, but may offer more rewards if you and your mentee need to study specific issues. The mentor in this case is obliged to do research to find the best information on the topic.

Not that I have researched it all, but there is a wealth of material available. You only need to go to a Christian bookstore to get some ideas. Most bookstore employees are more than willing to assist you in your search.

It might be helpful if you have some idea of the topic you want to pursue. But even if you don't initially, by the time you do a little research on the studies available, you will have a wealth of ideas to choose from. Once you get a few topics that pique your and your mentee's interest, the next step is to decide on your primary focus or the order of topics you will cover. This will be based on your mentee's communicated needs as well as your observations of her.

Study together: how, when and where. After deciding what to use and who will be in the group, if you decided to do a group, the next steps are to determine how, when and where. Ask your mentee or group for input. When I have done discipleship, the time we got together was mostly determined by the schedule of

the group. The larger the group, the harder it is to get a schedule that fits everyone. Sometimes it might work to say, "We're meeting the first Saturday of each month." Those who can make it will; those who can't won't.

Next decide how and where. "How" will you mentor? Not many of us—probably none of us—have the luxury of doing it the way Jesus did: he actually lived and traveled with his disciples 24/7. This lasted for about three and a half years. What a way to get to know someone and allow him to see your heart!

Though we may not be able to do exactly that, we can certainly use some of the principles in our efforts to disciple. How about a picnic? A lot of what Jesus did with his disciples centered around food. Not that we need more food in the African American community! Many of us struggle already with more pounds than we need. So how about a salad potluck or a session in which you make fruit and vegetable smoothies?

You can meet in your home. I did that for my first group discipleship effort. I've also walked in the park while discipling an individual. You can also meet in her home. With a group, try rotating homes. One group I was involved in used a hotel suite for quarterly meetings. Anywhere is possible, especially if you are discipling an individual. Mentoring can take place in a coffee shop, a mall, a car, a plane—you name it. It can take place almost anywhere you are able to carry on a conversation.

Some groups might want to incorporate games every now and then. These could be board games or games like charades. Movie nights are fun. The group that did an overnighter at a hotel about once a quarter would often play games and watch a movie over the course of a weekend, along with Bible study and catching up with one another.

A group that led to one-on-one mentoring. Two friends of mine, Shirley Baskins and Andrea Marzette, started a Christian

mentoring program for teen girls. They both had daughters who were struggling with things going on at school. Shirley says her daughter would ask her questions about drugs, sex and other things. Shirley and Andrea got together and brainstormed about what they could do, then they met together for about six weeks and developed a mission statement and a basic outline. Eventually it became a program called Ladies of Virtue (LOV), intended for girls ages thirteen to eighteen.

To invite participants, the leaders developed a letter and parent brochure because they wanted the parents to be fully aware of their plans. They also developed a brochure for women in their congregation whom they felt would be good as mentors and invited them to an orientation. Those who agreed to participate were asked to attend a three-hour training that explored the meaning of mentoring, key guidelines and tips.

The overall program content consisted of spiritual development, prayer and devotion and Christian integrity and lifestyle, covering topics from sexuality to academics, from healthy eating to personal finances. It began with rudimentary, introductory issues before getting to weightier matters.

The introductory session, attended by both mentees and mentors, was a sleepover with pedicures and breakfast. This allowed for relationship development in a welcoming, informal atmosphere. They then covered a number of topics, including characteristics of a mentor/disciple relationship, why mentoring and parental authority are important, and common misconceptions about mentoring.

Shirley says, "We didn't pair them up at first. The potential mentors came to sessions to get to know the girls. We asked the mentors to look for something in the girls that would give them a connection and a heart for the young lady. The potential mentors were encouraged to look for things they might have in

common, such as career choice, personality, family structure, attitudes—anything that would help them develop a heart for the young lady. The mentors came to us and said who they thought they wanted to mentor."

After that, they would inform the mentee about their potential mentor's interest in them. Most said, "Cool! She picked me?" I must attribute this, at least in part, to the thoughtful way that my friends went about planning and implementing their program. They gave much attention to the style of program they would operate as well as the substance, and they were able to create a welcoming atmosphere that allowed fun and socializing to serve as an entrée into deeper, more purposeful relationships.

ACHIEVE CLOSURE

Most discipleship relationships do not end. At the very least, you are continuing to pray for your mentee, and her for you. However, in an official discipleship relationship, there is a beginning and there is an end. Once the goals are accomplished, the official process can wind down. You may do this by intentionally getting together less frequently until you eventually stop altogether. It's better to set a time frame for how long you will be meeting at the very beginning of the relationship. After the length of time you have allotted to be in the mentoring relationship has come, determine if the initial goals have been met. If so, you can bring the relationship to an official close. If not, you can decide to continue.

A closing ceremony, a dinner together, even giving a certificate are all possible tools to use to commemorate the ending of the official discipleship process. After this, I encourage checking on the other person sometimes. And there will probably be informal contact: I've been invited to showers for mentees and for their grandchildren. I've been invited to wed-

dings. I've been invited to birthday parties.

It's good to maintain an open-door policy. The mentee needs to know she can call at different times in her life, and so does the mentor. I have maintained relationships with most of the members of the group that I initially discipled. I've talked to them on the phone. Some have been to my home since the meetings ceased. I'm thinking about doing a reunion so that we all can come together.

WORDS OF WISDOM

Gloria Ward began working full time in 1988 at Cedine Ministries, an organization under which my parents served as missionaries, many years after I left home. She was first exposed to Cedine when she was a camper in the fifties. She was in the sixth grade and responded to the plan of salvation by receiving Christ. But Gloria had no one to give her the discipling she needed. As a result, she became deeply involved in the world. She had a son when she was fourteen. She was a professional go-go dancer in her early twenties. She recommitted her life to Christ four years later and got a job as a policewoman. Miss Gloria, as we call her now, is in her mid-sixties.

Gloria is a forgiven single mom. She asked her son to forgive her for having him out of wedlock. It started a new phase in their lives. His attitude changed toward her.

Miss Gloria continues to have a burden for young people and women. She is especially burdened for abused women and girls in bondage from sexual abuse and molestation. She knows freedom is accessible, because she has become free from the same bondage. She wants to help others forgive people who have hurt them, so they can be freed.

Miss Gloria shares her words of wisdom in an acrostic of sorts. You might consider framing it as a closing gift to your mentee. I think it's a great way to sum up what the Christian life is about.

ENCOURAGEMENT

Enjoy Jesus now, while there is time.
(*Philippians 4:4*)

Neglect not the gift in you. We all have a gift. Use it for Jesus.
(*1 Timothy 4:1*)

Consecrate. Devote yourself totally to God while you
have a chance. (*1 Peter 1:15-16*)

Obey God. Don't fear man—only God.
(*Proverbs 3:1; Acts 5:29*)

Unmovable—be firm in God's work. Other young ladies
need you. (*1 Corinthians 15:58*)

Renew your mind daily. God's Word is powerful.
(*Romans 12:2; Hebrews 4:12*)

Abstain from all appearance of evil.
(*1 Thessalonians 5:22*)

Grow in the grace and knowledge of our Lord and Savior
Jesus Christ. (*2 Peter 3:18*)

Edify one another. Let's build up and not tear down.
(*1 Thessalonians 5:11*)

Meditate on Jesus daily.
(*Isaiah 26:3*)

Endure the test you've got to go through. God is with you.
(*Mark 13:13; 2 Timothy 2:3*)

Nourish your heart. Feed it God's Word.
(*1 Timothy 4:6; Isaiah 30:15*)

Turn everything over to Jesus. He'll make everything right.
(*Job 42:2; Jeremiah 32:26-27*)

May your heart and mind be strengthened with these words
of encouragement.

9

Confidentiality— A Cautionary Tale

—⁂—

*O*bviously, peer relationships do not offer the expanded wisdom that spiritual mother relationships do, but they do offer counsel or wisdom we are not able to have on our own. The Word of God tells us that in the multitude of counselors, there is wisdom (see Proverbs 11:14). At times, we may encounter situations when we need a little help. Sometimes, discussing things with a sister will help us sort out possible solutions. But when discussing people, we have to remember confidentiality issues. We should not mention names or problems in a way that the identity of our spiritual daughter is known. In no way should we compromise the integrity of our daughter relationships.

Dictionary.com says that *confidential* is "spoken, written, acted on, etc., in strict privacy or secrecy; secret; a confidential remark," or, "indicating confidence or intimacy; imparting private matters." Similarly, *confidence* means "as a secret or private matter,

Become an encourager, a giver, a good listener, a true friend. When a friend shares with you, . . . you become their prayer warrior. You share that with no one else but God.

Thelma Mason

not to be divulged or communicated to others." It is imperative that trust, which includes confidence and confidentiality, are major pillars of the discipleship process. They were not in the following case.

Burgundie, a friend of my daughter, shares the following story of a broken confidence:

> I am a twenty-four-year-old woman, and I've been searching for a mentor for the past two years. In mid-2008 . . . I went to an elder of our church (did not pray about it) that I respected and felt drawn to (let's call her Vaugn). The thing that is very unique about my church and my circle is that everyone is interconnected. So I went to Vaugn and asked her if she would be willing to mentor me. She said yes, and then it began.
>
> . . . I noticed that some weeks had gone by and I had not heard anything from Vaugn. I wasn't sure how our relationship was supposed to work, so I went by her shop to set up an appointment to meet with her. She made time for me right there on the spot. She took me to the back of her shop and started talking with me. We discussed what would be expected (briefly) and a few brief introductory concepts. I told her how important her role was for me for many reasons.

Burgundie explained to Vaugn that she was already mentoring eleven young women and had just become involved with a young man. She needed much guidance. Fortunately, the young man

was Vaugn's best friend's son. Or maybe not so fortunately.

Vaugn hardly ever called or checked on me; the one time she set up a meeting, she almost immediately canceled it. I knew she had some time; although she was a busy self-employed woman, she did go on outings with her best friend ("Maria"), whose son I was dating. When I would ask her why she never included me in their outings, she said, "Oh, I never thought about it."

Here comes the cautionary part of the tale.

As my relationship with the young man advanced, I really needed Vaugn more, but could never connect with her. She never seemed to have the time. After a few months, the young man began telling me that Vaugn and Maria had been discussing me with him and with one another. I never pushed him to give details. At first I wasn't offended, but as he continued to share their conversations, it started to bother me. I was hurt, confused and frustrated.

The consequences to breaching a mentee's confidence can be devastating to the mentee.

I began to shut down. It was hard to see them at church or in public and not feel angry because they would smile with me and never say a word as to what issues they had with me. As time went on, my anger grew into resentment and a loss of respect for my mentor. It hurt even more because I didn't have anyone to talk to about what I was feeling without worrying about the situation becoming more messy than it already was.

My issues with my mentor and her best friend placed a strain on my relationship, and it ultimately came to an end.

The response from Vaugn was too little, too late and just *wrong*.

A few weeks later I received a call from Vaugn saying that we needed to talk. As soon as we met, she started off with all the things she assumed to be true, based on what she had heard through various sources. She never asked me how I felt . . . was any of it true . . . when I did finally have a chance to share with her my side. "What did you say exactly?" she asked me. I told her it wasn't important, and that I felt like she had breached my trust and misused her position. I had given her authority to bring to me whatever was necessary for growth, even the things that are uncomfortable and painful. She responded that she should be able to discuss with her friends what friends discuss and that she had an obligation as a leader to share harmful things with whoever in the church she deemed appropriate.

> I discovered the cross of Jesus Christ is more than a place to leave my sin. The cross is also a place to leave past mistakes, pain, hopelessness, doubts, worries, confusion—whatever is weighing me down.
>
> *Victoria Johnson*

In the end, she told me it was up to me to decide if I wanted to continue our relationship. I left feeling unsure, uncomfortable and uneasy.

Fortunately, the two parties allowed God to intervene. But the relationship would never be the same.

God has since then restored our relationship and caused reconciliation. But I never returned to the mentoring relationship I originally tried to establish. She is someone who I still respect, and I've forgiven her and am able to love her from a pure heart. No hard feelings, but she is not and will not be my mentor.

When you are a part of another person's life, there has to be trust. Confidentiality must never, ever be breached. Your mentee should be able to share with you without wondering or fearing that you will tell someone else the things she told you in confidence.

I believe spiritual sisters do help us in the mentoring process, but we need to be very careful when we are sharing things about those we are mentoring with those who are our sisters and even with those who are our spiritual mothers. Sometimes we may need help with a situation, but we need to respect the woman we are mentoring and either ask permission to share with someone else or share without mentioning names or giving details that will make our mentee's identity clear.

There are a few situations that warrant enlisting others, which might not involve getting permission to report. In instances of child abuse, elder abuse, threat of suicide or harm to others, one is morally obligated to report these situations to authorities. Just be sure that you are reporting facts you have observed and not reporting hearsay.

HOW TO MAINTAIN CONFIDENTIALITY

So how should we discuss our mentee relationship issues with our spiritual sisters? First, be open with your mentee. Tell her from the beginning that you are in relationships with sisters who are available to you for help when you need it. Let her know that you may discuss her challenges with others without mentioning her name, but that you would never discuss sensitive issues without her permission. Tell her that you will not even do that if she feels uneasy about your discussing even the more generic issues with others. Indicate that you will always respect her wishes.

When it is a sensitive issue that you really feel you need help

with, simply ask your mentee for permission to share. If she does not grant the permission, let her know that you would like to share her story or challenge in a way that the sister could not possibly figure out who you might be referring to. Reassure her that you will not do anything to reveal her identity, and then make sure you stay faithful to that reassurance. Your relationship may depend on it.

He who covers over a transgression promotes love, but he who repeats a matter separates close friends. (Proverbs 17:9)

10

The Ultimate Example

How do women disciple others? How do women become disciples? To answer that, we'll look at the life of Jesus—the master discipler—and his disciples for clues.

But first, a question: is discipleship even mentioned in the New Testament? I would say it's more than mentioned. It's demonstrated by the actions of Jesus. He chose a group of twelve men to spend time with. He subsequently spent even more time with three out of that group of twelve. Likewise, the apostle Paul spent time with different men, such as Titus, Timothy and Barnabas.

SPENDING TIME

But Jesus withdrew with His disciples to the sea. And a great multitude from Galilee followed Him. (Mark 3:7)

Jesus spent time with the multitudes, teaching them. And his disciples were with him when he was with the multitudes. They heard what he taught. But there were times Jesus sent the

multitudes away and just sat with his disciples, with no one else around. Sometimes he expounded or expanded on what he taught the multitudes. Sometimes the disciples asked Jesus to explain things a little better.

Both Jesus and his disciples had to be willing to spend time together. When Jesus called them into a discipleship relationship, they each had to make a decision to leave what they were doing and spend *time with him.*

> The following day Jesus wanted to go to Galilee, and He found Philip and said to him, "Follow Me." (John 1:43)

> And He went up on the mountain and called to Him those He Himself wanted. And they came to Him. Then He appointed twelve, that they might be with Him and that He might send them out to preach. (Mark 3:13-15)

In a discipleship relationship, you have to be willing to get together. Time is our greatest investment. What exactly do you do when you spend time together with the people you are mentoring or being mentored by? Jesus was intimate with his disciples, more than with anyone else with whom he interacted. He told them more than he told anyone else.

When Jesus' disciples did not understand the things he taught, they asked him to explain things to them after the crowds left. He would from time to time break down the things that he had taught in public to his disciples in a way they would understand.

He also began to tell them things he did not say to others, including many things about what would be happening to him in the near future.

> From that time Jesus began to show to His disciples that He must go to Jerusalem, and suffer many things from the

elders and chief priests and scribes, and be killed, and be raised the third day. (Matthew 16:21)

TEACHING THE WORD

The second thing Jesus did with his disciples was teach them the Word. Teaching the Word is an integral part of Christian discipleship, yet this does not have to take place in Bible study. Any conversation can be full of the wisdom of the Word. Jesus taught the Word in many ways, and so can we.

> But without a parable He did not speak to them. And when they were alone, He explained all things to His disciples. (Mark 4:34)

I was in California with Jasmine, putting the final touches on my message, when the Lord changed the message. He gave me a fresh word about the difference between goals and purpose. I knew it was a word particularly for me, because it ministered to me for the situations I found myself in. So I shared this word with Jasmine.

It wasn't planned, but in our time together, I taught the Word. It was just part of the process. I didn't say, "Here, Jasmine, I have something to teach you." Instead, I just shared with her as I was walking out my own life. I don't remember Scripture and verse, but I believe Jasmine learned some things about God through the course of the conversation. In fact, I know she did. She told me so.

> Study God's Word daily, meditate on it, pray always. Don't fret. Trust his Word, stand on his promises, rest and wait. Don't move. Be completely still, inward and outward. Wait.
>
> *Thelma Mason*

MODELING A RELATIONSHIP WITH FATHER GOD

The third thing Jesus did with his disciples was to model his relationship with his Father.

> And when He had sent the multitudes away, He went up on the mountain by Himself to pray. Now when evening came, He was alone there. (Matthew 14:23)

> And it happened, as He was alone praying, that His disciples joined Him, and He asked them, saying, "Who do the crowds say that I am?" (Luke 9:18)

> He went a little farther and fell on His face, and prayed, saying, "O My Father, if it is possible, let this cup pass from Me; nevertheless, not as I will, but as You will." (Matthew 26:39)

When they were with Jesus, the disciples saw him communicate with his Father. They saw him find time to be alone with his Father. They saw how his relationship with his Father affected him in a crisis—he slept in the midst of a storm. They saw him communicate honestly with his Father when his will and his Father's were different. They observed the vast amount of time he spent alone with his Father, and they were there when he asked the Father to let the cup pass from him.

Jesus did not hide his struggles from his disciples, even when those struggles were with God the Father himself. He did not hide his intimacy with his Father, his conflicts with

> The thing that keeps coming to me is "trust in God." Through all of my adversities and all the things I have gone through, I had to keep trusting God. You have to say, "Lord, I believe, but help my unbelief."
>
> *Sister Odell*

his Father or his trust in his Father from his disciples. Likewise, people who disciple younger people have to be willing to allow those they disciple into their lives.

Jesus discipled a group of twelve men. I tried to disciple a group of twelve women, and it wore me out. When I mentored them, they were in my home. They had the opportunity to observe my relationship with my children and my husband. They saw that I was not a good housekeeper. They saw the raw me. They saw how I balanced ministry (whether successfully or unsuccessfully), home, family and my personal life. It wasn't all pretty, but that's part of discipleship. Discipleship is not about being without faults. A fear of people seeing your imperfections is no reason to shy away from mentoring others or from being mentored.

My relationship with my Father has had some real struggles. Jesus struggled, too, as evident in the Garden of Gethsemane, but my struggles have been different in nature. Once when I had received some not-so-good news from my doctor, I really did not want to talk about it, but I ended up sharing it with a group that I was mentoring with Gina. They prayed for me, and it was comforting.

There were times when I had to deal with my misgivings with God. I shared these with different groups of women that I was discipling. Many times, the group would respond with prayer. God would eventually bring me out of the fog and I would share that with the group as well. Once I remember being really unsure about direction. There were a number of things happening that caused me confusion. One of the young ladies in the group shared some words that God gave her for me. The words were so reassuring that I asked her to write them down and give them to me. She did, and I have read them at other times and found comfort in them. So those I mentored

were able to observe my weakness—and God's faithfulness. I had been saying, "It's not about me." And it really wasn't.

DOING THE WORK

Another thing Jesus did in front of his disciples was "the work." He did what God had called him to do in front of those he mentored. As mentors, we need to be willing to have those we mentor see us fulfill what God has called us to do. Those I have mentored have gone with me on speaking engagements as individuals and as groups. They have observed me fulfill the call of God on my life. At times, when I have a writing assignment, I am able to get away to a room or to a cottage at the mission in which I grew up, and I can dedicate the time to writing. Although on most occasions, I go alone, sometimes a friend has gone with me.

Sometimes we may not know the impact of the time we spent with someone. One young woman writes,

> Most older black women don't really take an interest in me or what is happening in my life, or care enough to get to know me, and I'm not sure why. Maybe it's because they feel like I live in a nice suburb so I shouldn't have any problems or that because I go to a "good" school I should be okay. But to be honest, I have as many issues as the next person. Living with a sister whose constant struggle with depression takes most of my parents' attention, leaving me feeling upset and somehow guilty for it, isn't my idea of "okay." Neither is the fact that I constantly feel lonely and like no one really cares.
>
> Throughout the years I have had a lot of relationships with older African American women, but honestly most of them were insignificant and short-lived. Only a few of my

relationships with women around me have stood out in my mind, but none have impacted me as much as my relationship with Ms. Raynetta.

Ms. Raynetta is a Sunday school teacher at my church. One day when she was teaching one of her lessons, it just made me really emotional, so I wanted talk to her after class about some things that were taking place in my life. At first I was hesitant to talk to her, but then I began to share about how I always felt lonely and like people were leaving me. She made me feel totally comfortable talking with her. After I told her this, she took a sudden interest in my life and gave me Bible verses to read about people throughout the Bible who had similar issues to me. She also gave her number and email so that if I ever needed to talk to someone, she was there.

Our young friend found wisdom and was able to grow—and it all happened because Raynetta was there to ease her way.

Because she made me feel so comfortable talking with her, I began to share things with her that I hadn't told anyone else about my family and myself, because I felt like she actually cared. Knowing that someone cared enough to take out time to spend with me and just talk to me about what was going on made me feel really special and loved.

She would tell me how even when everything seems to be going wrong, it is for a reason and God has a plan for me. She made me look at my life in a different light; I always saw the negative side of things, and she somehow made them seem positive. I believe God placed her in my life at this time because so many things have been going on, and I've been so confused and upset. I believe he put her there to help guide me in the right direction.

And what had Raynetta done to connect with women? Did she have some grand "master plan"? Did she take out an ad in the *New York Times* announcing that she was looking for disciples? Did she even make an announcement in church? No. She was just walking in "the way," being obedient to the Holy Spirit. He led this young lady and others to Raynetta, and she was compassionate and open and shared her wisdom. That's how you make a "holy connection."

I met Raynetta before her relationship with her young mentee, when I volunteered with Transition of Prisoners (now known as New Creations Community Outreach). She was out of prison and attended a weekly Bible study I did for a while at that ministry. She loved Jesus and really wanted to grow in the Lord. After meeting her in those classes, I didn't see her for a while, but met her again last year. She now attends the church I used to attend.

Raynetta knows the value of having a mentor and has sought them out. She gives back too. She has a group of young women that she pours her life into. She doesn't like to say she's their mentor and they are her mentees. She just does what she does. But her reward comes when she realizes the impact she has had on their lives.

Raynetta was surprised to see the impact she had on the young woman above. But she was even more surprised when the woman's father came to church one day and spoke of the difference he had seen in his daughter's life as a result of Raynetta's taking time with her. Raynetta saw that her labor was not in vain.

THE RESULT OF FOLLOWING JESUS' MODEL

As we understand some of the dynamics that went on between Jesus and his disciples, we better understand the dynamics of

our discipleship relationships. The disciples of Jesus understood they had a relationship with him. As a result of being disciples of Jesus, they followed him: "Now when He got into a boat, His disciples followed Him" (Matthew 8:23). They also made requests of him; they looked to him for help. They respected him as one who was able to do more than they themselves could do. When they faced a storm on the waters, they turned to Jesus to keep them from disaster.

The people we disciple will ask us for help. They may ask us for a recipe or to teach them how to cook, or they may ask us how to study the Bible. After witnessing me working on several books over the years, one of the women in my discipleship group asked me to help her write a book.

You never know what the results of your discipleship will be. I recently began praying with two members from the group of twelve from a few years back. Prayer has been a part of the ministry God has given me. I have taught on prayer; I have prayed alone and with others.

Simply trust the Lord. I often ask the Lord to help me to trust Him. As I have grown up and have had a chance to look at life and the transitions I have encountered—family, church—each transition brings another level of trusting the Lord.

Verna Holley

So at times others have come to me to pray with me because they have observed the prayer ministry God has called me to. Just as Jesus' disciples came to him for help based on the things they had seen him do, the people we disciple will come to us.

Jesus counted his disciples as his own family. They were very close to him, but not above him. He said, "A disciple is not above his teacher, nor a servant above his master" (Matthew 10:24). And "He stretched out His hand toward His disciples

and said, 'Here are My mother and My brothers! For whoever does the will of My Father in heaven is My brother and sister and mother'" (Matthew 12:49-50).

In Jesus' example of his relationship with his own disciples, we find valuable instruction as women who want to spend time with the younger generation. We mentor according to what Jesus did with those he discipled: (1) we spend time with them; (2) we teach the Word; (3) we model a relationship with the Father; and (4) we do the work in their presence. Most importantly, we are intimate and transparent with our mentees about our relationship with God.

11

A Real-Life Mentor Model

—⟨♦⟩—

*I*n the process of writing this book, I called Pat Soares, a friend and member of Chosen Vessels Ministries board, to ask her about discipleship. When I mentioned what I was up to, the name Ruth Sims immediately rolled off her tongue. She began to tell me about how she studied the Bible under Ruth and how many people became saved as Ruth brought busloads to a local women's conference.

She was not the first person who mentioned Ruth Sims. Mary Cleveland Evans, a friend and Detroit school teacher, had also mentioned her name as a discipler in their life. Both Pat and Mary had been involved in Bible studies with Ruth for about twenty years. I had met Ruth before, but did not realize how rich her life had been.

Ruth deserves a chapter all to herself, and that's what I'm giving her. Read Ruth's story below and learn—and above all, praise God for someone who has been a faithful and obedient woman to the word given to us in Titus 2:3.

The "old-time" saints have a saying: "To let God use you, all you have to do is just be in the Way." That's *Way* with a capital W—that is, walk in the way God directs you to walk.

And that's Ruth. She's in her seventies now, having accepted Christ at the tender age of fourteen, so she's been "in the Way" a long time.

JUST "DOING HAIR"

It started with Ruth just "doing hair." She made a living as a hairdresser for more than forty-five years. Her temple was her beauty shop, wherever it might be located, usually in her basement. "Women would walk in, and I could tell if they were hiding something, or in pain," she explains.

Too often, the problem they were hiding was past molestation—by men who should have been caring for them, like fathers, uncles or cousins. Other women "just started reaching out to me," Ruth says.

To hear from God, she prayed. "I would always ask, 'Lord, let me know when to give you. Let me know when to bring you in.'" As Ruth talked with women, "the occasion would just present itself. I'm always looking for that occasion—a way to bring him in."

After a while, the questions came. "I was very open with the women I served as a hairdresser," Ruth explains. "I told them about my struggles, and eventually—sometimes right away, sometimes not—they would just start opening up. I found that most of them just needed acceptance."

But Ruth gave them much, much more than acceptance. She gave them Jesus. "I've had women in the beauty shop get on their knees and ask Christ to come into their heart. They would tell me, 'I never knew I had to do this.'"

She continued, "A lot of these women are like apples ready

to fall from the tree. I find that I usually have to meet a need first." And did she ever meet needs. Some of her pet names for those she helped are related to food—Peaches and Corn and Pumpkin—names for men and women who needed more than most, sometimes even more than their own relatives were willing to give. One was urged by her family to go into rehab, but she said she wouldn't go unless Ruth and her husband took care of her child. And so they did for a year.

PROVIDING SHELTER AND BIBLE CLASSES

When the woman came out of rehab, she was better, but she needed a place to stay. So Ruth and Tom kept her and her baby for a while longer. It didn't seem to end. "Most husbands wouldn't stand for it, but Tom gave me the freedom to do what God was calling me to do," Ruth says. She smiles wistfully— Tom passed away in 2000. She still calls him her "sweetie."

Ruth has provided shelter and counsel to more women than she can remember. She started a weekly Bible study that continued for more than fifteen years. This year, the thirty-plus women who were in that study are having a reunion to reconnect with each other and to thank the woman who helped launch many of them in various ministries in their homes, in their jobs and in their churches.

"Nana [what many of her younger mentees call Ruth] took us systematically through the Word, and it transformed us," remembers Mary. "We started with the Navigators [a Christian discipleship organization] materials. We began with the lessons about the assurance of our salvation and what it was to have a relationship with God through Jesus Christ."

After that, Ruth focused on Scripture memory and the importance of a daily quiet time. She used memory aids like the Hand Illustration (Hear, Read, Study, Memorize, Meditate) and

the Wheel (Worship, Fellowship, Prayer and the Word). She taught the women how to develop their own personal testimony and witnessing style, and how to forgive and to restore fellowship with God. And finally she taught them how to multiply themselves by leading others to the Lord and discipling them.

But what Mary remembers most is the "meat classes. Ruthie had us study two books that really impacted the way we saw life. The first was a book called *Fulfillment*, and it laid the groundwork for virtually every relationship that a woman has, from her parents to her friends to her husband to her children, and then to herself and her God," she explains. The second book, *Behold Your God* by Myrna Alexander, was an eye-opener—a "heavy" book, as Mary puts it. "It went through all the attributes of God. If you know him, really know him, you are pressed into maturity."

DUPLICATING HERSELF

But the real teaching, as all true teaching, was done—and is still being done—by example. "Ruth taught us how you could bring the Lord into your secular profession," says Pat, who plans to attend the reunion. Pat would know. She has taught Bible study classes at her place of employment, and women with whom she works come to her often for counsel and prayer.

Ruth acknowledges that her passion for mentoring younger women did not happen in a vacuum. A dear friend, Ron, now a pastor in Ohio, was introduced to Ruth by a mutual friend and was impressed by the informal counseling work she was doing in her home. "He said, 'Every time I come to your house I see people coming for counsel. Half of them really want to change, and half don't. If you let me do a Bible study here, I'll help you find out which is which.'"

She agreed. Soon, just by picking up Ron's method and style of teaching, she was leading her own Bible study group. Before long, she and Mary, who was in that first Bible study group, were writing Christian-living and evangelistic tracts together. "Working side by side in ministry is the most effective discipleship of all," Ruth says.

It seems odd, doesn't it, that a younger Christian man might provide mentoring and support to an older Christian woman? But not to Ruth, nor to her husband. "It was a mutual kind of thing," she explains. "He was like a son to Tom and me, but he also taught us the Word in a very powerful way."

Ruth and Mary have a similar relationship. "Ruthie has helped me in ways that no one knows," Mary says. "But I've intervened on her behalf too." Intervened, that is, when Mary felt that Ruth was letting people go too far in their solicitations for help. "I would sometimes tell Ruth, 'They've been here long enough. You need to have them pay you at least something. If not, designate a kitchen time where they can cook their own meals—with food that they've bought themselves," she explains.

After all, sometimes the most important part of mentoring is learning when to let go. "I would always counsel a married woman to follow her husband," Ruth explains. "One woman was a member of my church and didn't want to leave, but her husband did. She didn't want to leave because she wanted to stay close to me, but I let her know that she had to separate from me in order to grow—and to stay 'in order' with God."

MENTORS ARE MADE, NOT BORN

Like any other Christian, Ruth didn't start out fully mature when she accepted Christ at fourteen. "I had a father who was verbally abusive, and he seemed to focus most of his verbal abuse on me," she remembers. She was one of ten children, with

both parents in the home, and she wondered why her father singled her out in particular. "He called me stupid and skinny and black" (*black* was an insult in that era).

Later, in Ruth's adulthood, she was ministering at a church where the pastor challenged his lay leaders to write their autobiography. "I couldn't bring myself to do it," she says. "Then one day, all of a sudden, I sat down and asked the Lord to take me back. I wrote five pages, the tears streaming from my eyes. I was ashamed to read it." But it was that five-page autobiography that launched her healing and deepened her life's message. "I felt like the biblical writers; I was writing as I was moved by the Holy Spirit. The Lord healed me with that," she said.

Almost. It wasn't long before the Lord started to challenge her about her father: "'Now that you've written about your pain, you have to go to your father and forgive him,' the Lord told me."

Ruth wasn't too eager to obey. "Why do I have to make the first move?" she asked God. "He's the one who hurt me." But she went.

She was bold and scared at the same time. "Dad, you know when I was little when you used to call me stupid and skinny and black? Well, I believed you. When I would get to school, I wouldn't do my work because I thought I was stupid."

Her dad started crying. Ruth continued, "I could have gotten As and Bs, but I believed you." Then she started to cry too.

Her dad finally explained himself: "When I was young I left home because my dad talked to me like that. But when you were born, you were so kind. I felt I had to talk to you like that to make you strong so you would survive."

"Dad, I'm a mother now. So I understand."

She continues. "Eventually my dad had Alzheimer's. Tom and I brought him home to take him off my mother's hands for a few days. He told me, 'I trust you with my life.' I had witnessed to

him my entire life, but he always would rebuff me. Then one day, Mom told me, 'Your dad wants to come to church, but he won't come with anyone but you.' Tom and I went to get him. When it was time for the altar call, I said, 'Dad, do you want to accept Christ today?' He said 'As long as I don't have to go up there [to the altar].' I gave him the plan of salvation right there in the church pew, and my dad prayed to receive Christ that morning."

> The hymns we sing have new understanding. Sometimes the words come into my mind as I work around the house. I'll sing, and the words of the song speak to my need. The words remind me of who God is and his influence in my life.
>
> *Verna Holley*

MINISTERING TO OTHERS

"After God healed me, I began to read women," Ruth said. "I could tell right away who was wearing a mask." She's been reading women—no, people—ever since. Each of her three homes—she now resides in a well-appointed suburban Detroit condo—has been a second home, for a day or a week or a year, to men and women and children in need, from alcoholics to those tortured by drug addiction to entrepreneurs.

Ruth has developed the true compassion that comes from hurting deeply, forgiving deeply and loving deeply. Men, women and children alike are drawn to her open and giving spirit.

But Ruth's heart is for women. And not just African American women. Mary explains: "One day, I was at the store getting some gym shoes for my daughter. I was asking her, 'Did you call Nana?' Next thing I knew, a white woman snapped her head around and said 'Nana? You know my Nana?' Sure enough, she happened to be a woman at Ruth's new church to whom Ruth had ministered."

Mary was surprised, but not very. "Ruth just has that mothering spirit."

WORDS OF WISDOM

You've met Ruth Sims in this chapter. You know she is a retired hairdresser. You also found out she is a widow. She is seventy-three, and with two daughters, she has seven grandchildren and five great-grandchildren. This is her favorite verse: "Cast thy burden upon the LORD, and he shall sustain thee: he shall never suffer the righteous to be moved" (Psalms 55:22 KJV). We conclude with her words of wisdom:

> Don't think of ministry as being something you do in the church or in religious circles. I've learned that everything we do is ministry. We are supposed to do everything as unto the Lord. So all parts of our lives, whether it's our friendships, our children, our jobs, our neighbors, are ministry. For instance, if we don't like our jobs, but our focus is on our jobs being ministry, it will make it much easier for us to cope.

Being a great discipler, Sister Ruth certainly has something to say about disciplining others. She wants us to remember to pay attention to horizontal and vertical relationships. Horizontally, make sure you keep the vision of the Great Commission going by teaching those you mentor how to disciple others too. Help them to keep passing the torch on. As Paul admonished Timothy, "And the things that you have heard from me among many witnesses, commit these to faithful men who will be able to teach others also" (1 Timothy 2:2).

As far as our vertical relationship goes, be like Jesus, who spent time alone with his Father: "And when He had sent the multitudes away, He went up on the mountain by Himself to

pray. Now when evening came, He was alone there" (Matthew 14:23).

Ruth wants to make sure you have quiet time alone in the Word and in prayer for your own strength and motivation. "We have to have a vibrant relationship with God to find out what he wants us to do next," she says. "With all that is going on in the world, it's easy to get weary. We need to have Scriptures in our lives as a means of strength and direction."

What a fitting way to close: with a model for discipleship that we all can follow.

Let's be about our Father's business of helping women mature in their walk with the Lord. My prayer is that women will intentionally invest in the lives of other women so that the whole body can be better equipped. My prayer is that no one would have an excuse of not knowing what to do. My prayer is that every woman, young and old, would find a spiritual mother—and be one too.

Appendix A

The Road to Salvation

There was a man of the Pharisees named Nicodemus, a ruler of the Jews. This man came to Jesus by night and said to Him, "Rabbi, we know that You are a teacher come from God; for no one can do these signs that You do unless God is with him."

Jesus answered and said to him, "Most assuredly, I say to you, unless one is born again, he cannot see the kingdom of God."

Nicodemus said to Him, "How can a man be born when he is old? Can he enter a second time into his mother's womb and be born?"

Jesus answered, "Most assuredly, I say to you, unless one is born of water and the Spirit, he cannot enter the kingdom of God. That which is born of the flesh is flesh, and that which is born of the Spirit is spirit. Do not marvel that I said to you, 'You must be born again.' The wind blows where it wishes, and you hear the sound of it, but cannot tell where it comes from and where it goes. So is everyone who is born of the Spirit." (John 3:1-8)

I'm going to review a popular summary of the gospel called the "Romans Road." Every verse comes from Romans. It begins . . .

For all have sinned and fall short of the glory of God, being justified freely by His grace through the redemption that is in Christ Jesus. (Romans 3:23-24)

For the wages of sin is death, but the gift of God is eternal life in Christ Jesus our Lord. (Romans 6:23)

Now that we know the consequences of sin and the fact that God has made a provision of eternal life in Jesus, the next step on the road tells us about that provision.

But God demonstrates His own love toward us, in that while we were still sinners, Christ died for us. (Romans 5:8)

So Christ died for us. What response should we have? How do we get from where we are to where we need to be? The next step on the Romans Road leads us there. It tells us what we must do.

If you confess with your mouth the Lord Jesus and believe in your heart that God has raised Him from the dead, you will be saved. For with the heart one believes unto righteousness, and with the mouth confession is made unto salvation. (Romans 10:9-10)

This is a two-step process, confessing with our mouths and believing in our hearts, which is the final step. It's the culmination point to the whole process. It explains in a little more detail the confessing with your mouth and seals the deal.

For "whoever calls on the name of the Lord shall be saved." (Romans 10:13)

Appendix B

Evangel Church Discipleship Program

VISION AND MISSION

Vision. A reformed church where every member is fully grown in his or her purpose, personality and philosophy, laboring with others until Christ is formed in them.

Mission. Evangel Ministries aims to create a discipleship movement in the church where each member is plugged into one of the three discipleship ministries (men's, women's, children's), becomes a *disciple* of Christ and reproduces himself or herself in others.

MISSION OF EVANGEL MEMBERS

Members should be *disciples*:

Devoted to Christ

Involved in an accountability relationship

Serving in ministry

Community minded

Increasing in the fruit of the Spirit

Pursuing your purpose

Learning to lead

Engaged in biblical training

Sacrificially giving

My Sister's Keeper Discipleship Ministry

MISSION

The older women likewise, that they be reverent in behavior, not slanderers, not given to much wine, teachers of good things—that they admonish the young women to love their husbands, to love their children, to be discreet, chaste, homemakers, good, obedient to their own husbands, that the word of God may not be blasphemed. (Titus 2:3-5)

My Sister's Keeper Discipleship Ministry (MSKDM) equips Christian women through trainings to identify, seek and disciple other Christian women who are willing to commit to a discipleship relationship of one-on-one, in-depth faith meetings, fellowship times and family gatherings until Christ is formed in them.

VISION

Every woman in Women of Purpose will be mature because of her discipleship relationships that empower her to reproduce Christ in herself and others, and this maturity will be reflected in behavior that is holy, righteous, sober, discreet, virtuous and loving toward their family and others (see Titus 2:3-5).

JOB DESCRIPTIONS

DISCIPLER

Position overview: Disciplers are responsible for developing the members of the local church in the twelve critical discipleship areas outlined by the church.

Reports to: Discipleship Coordinator

Spiritual gifts: Teaching, giving exhortation

Position may be filled by: Members who have completed the FTP and are actively involved in a discipleship ministry.

Job description: The following is a list of vital tasks that the discipler shall be responsible for accomplishing.

TIME TASKS
Discipler must provide the disciple with
- Faith
- Fellowship
- Family time

TALK TASKS
Discipler must provide the disciple with
- Annual goal-setting talks
- Monthly evaluation talks
- Weekly encouragement/relationship-building talks

TEACHING TASKS
Discipler must teach their disciple
- Theological skills
- Family life skills
- Ministry skills

DISCIPLE

Position overview: Disciples are responsible for totally submitting to the discipleship process and complying with all assignments and tasks given them by their discipler.

Reports to: Discipler

Character qualities: Submissive, diligent, humble and hungry

Position may be filled by: Member who has been deemed to be FIT for discipleship.

Job description: The following is a list of vital tasks that the disciple shall be responsible for accomplishing. Must also be willing to serve as a pre-discipleship facilitator for at least six months.

TRIMMING TASKS
Disciple is responsible for trimming:
- Out of their schedules all events and activities which may interfere with their discipleship process.
- Out of their life any person who may interfere with their discipleship process
- Out of their life any attachments that may interfere with their discipleship process

TRANSITIONING TASKS
Disciple must transition their
- Schedules to a discipleship-driven time-management system
- Families to a discipleship-sensitive family structure
- Priorities to a discipleship-based model

TRAILING TASKS
Disciple must trail their discipler's
- Lifestyle
- Teachings/Philosophies
- Ministry

THE TWELVE KEY GOALS OF DISCIPLESHIP

1. *Comprehension:* Helping your disciples to develop a holistic and practical understanding of God's Word, will and way

2. *Commitment:* Helping your disciples to completely and consistently dedicate themselves to God's seasonal assignments for their lives

3. *Consistency:* Helping your disciples to develop a steadiness and faithfulness in fulfilling their kingdom roles, rules and routines

4. *Character:* Helping your disciples to develop consistent biblical integrity in everything they say and do

5. *Convictions:* Helping your disciples to accept and adopt biblical beliefs and boundaries in all areas of their lives

6. *Communication:* Helping your disciples to develop their communication style and substance into something that's scriptural, strategic and Spirit led

7. *Communion:* Helping your disciples to develop consistent times of quality fellowship and worship with the Lord

8. *Contentment:* Helping your disciples to develop an ongoing tolerance and thankfulness for God's policies, projects and provisions for them

9. *Confidence:* Helping your disciples to develop an unusual amount of trust in what God has promised to do for them and others

10. *Courage:* Helping your disciples to develop and demonstrate a brave and bold spirit in their Christian living and service to the Lord

11. *Competence:* Helping your disciples to develop a spirit of excellence in their understanding and use of their natural talents and spiritual gifts

12. *Companionship:* Helping your disciple to develop and maintain relationships with people who will have a positive and prophetic impact on them

LEADERSHIP DEVELOPMENT BASE PATH

Evangel's Leadership Development Base Path is the process of growth for members, particularly leaders, at Evangel Ministries. The Base Path consists of three levels:

- *First Base (pre-discipleship).* At this level, members can participate in a range of programs designed to provide foundational training for those who desire to live a committed, dedicated life of Christian service. These programs are attended by the largest number of individuals in the discipleship ministry, and consistent participation establishes a baseline standard for qualifying to go on to further programs.

- *Second Base (large-group discipleship).* At this level, participants maintain their attendance in the baseline programs at the First Base level and add more intensive leadership/institute training.

- *Third Base (personal discipleship).* This level is for those who have expressed an interest in participating in individual and small-group discipleship training. Participants are evaluated for their readiness to move to leading disciples themselves. Women who have expressed interest in discipleship are monitored for their FITness level. Potential disciplers should have a reputable faith testimony, solid integrity and a history of sound teaching.

FOUNDATIONAL TRAINING PROGRAM (FTP)

The Foundational Training Program gives Evangel members the foundation they need in the Christian faith and explains the doctrine of Evangel Ministries. Even if you are a seasoned Christian, you should attend these classes to become familiar with your church and be a blessing to others. Current FTP

classes are New Members (101), Developing Spiritual Maturity (201) and Discovering Your Ministry (301).

Monitoring. Attendance is taken at all classes/ministry programs. To be considered faithful and to participate in the next level of ministry training, participants must attend at least twice per month. Similar attendance monitoring will take place at the Thursday night service.

Whom should I contact if I have questions? Participants have a primary point of contact, as well as a leadership team of women that they can call if the primary contact is not available.